Contemporary Coast Salish Art

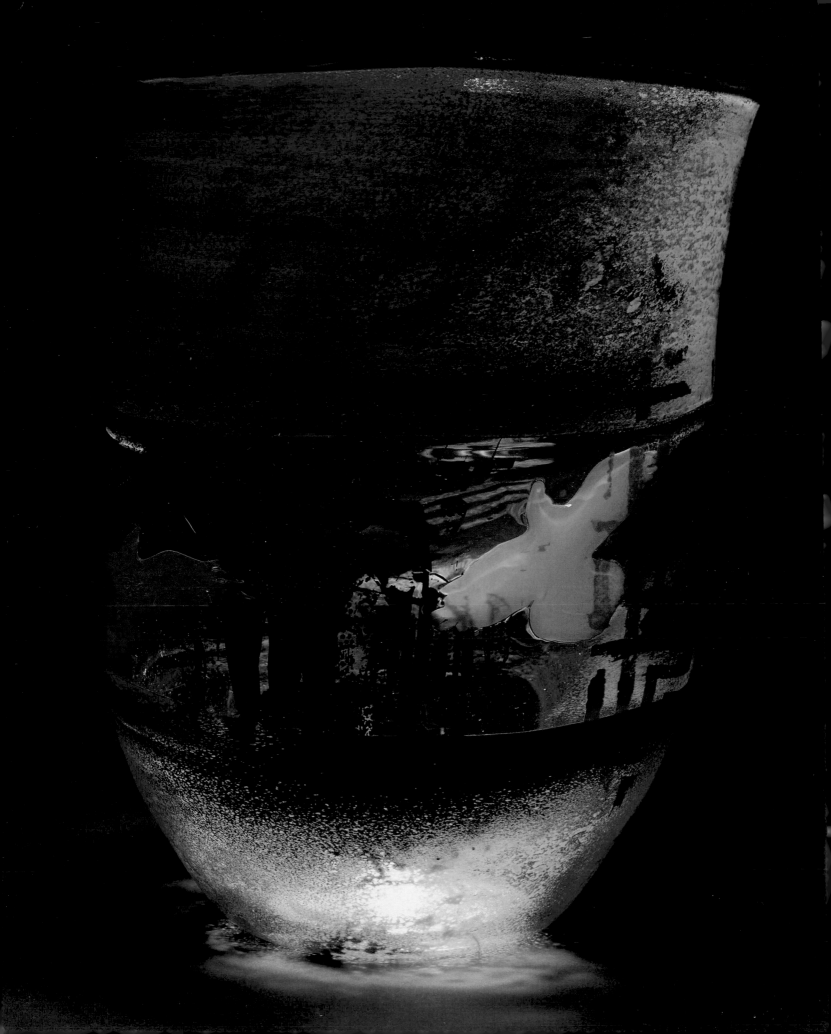

Contemporary Coast Salish Art

EDITED BY REBECCA BLANCHARD & NANCY DAVENPORT

WITH SPECIAL EDITORIAL ASSISTANCE FROM STEVEN C. BROWN

PHOTOGRAPHY BY MIKE ZENS

STONINGTON GALLERY SEATTLE

IN ASSOCIATION WITH

UNIVERSITY OF WASHINGTON PRESS SEATTLE & LONDON

Copyright © 2005 by Stonington Gallery

Printed in China

Designed by Audrey Seretha Meyer / Map designed by Deborah Reade

Unless otherwise noted, all photographs by Mike Zens

10 09 08 07 06 05 5 4 3 2 1

Published in conjunction with the exhibition "Awakenings: A Gathering of Coast Salish Artists," organized by the Stonington Gallery, August, 2005.

Stonington Gallery / 119 South Jackson Street, Seattle, WA 98104
www.stoningtongallery.com

University of Washington Press / P.O. Box 50096, Seattle, WA 98145
www.washington.edu/uwpress

Library of Congress Cataloging-in-Publication Data
Contemporary Coast Salish art / edited by Rebecca Blanchard and Nancy Davenport ; with special editorial assistance from Steven C. Brown ; photography by Mike Zens.—1st ed.
 p. cm.
Catalog of an exhibition organized by the Stonington Gallery, August, 2005.
Includes bibliographical references.
ISBN 0-295-98486-4 (hardback : alk. paper) — ISBN 0-295-98485-6 (pbk. : alk. paper)
1. Coast Salish art—Exhibitions. I. Title: Exhibition title: Awakenings, a gathering of Coast Salish artists. II. Blanchard, Rebecca. III. Davenport, Nancy. IV. Stonington Gallery (Seattle, Wash.) V. Title.
E99.S21C65 2005
704.03'9794—dc22 2004027265

The paper used in this publication is acid-free and recycled from 20 percent post-consumer and at least 50 percent pre-consumer waste. It meets the minimum requirements of American National Standard for Information Sciences-Permanence of Paper for Printed Library Materials, ANSI z39.48-1984.

Cover: **Transporter,** 2004, Marvin Oliver. See fig. 31, p. 44.
Endsheets: Shadow detail of **Return,** 2003, Susan Point. Sand-etched glass, red cedar, stainless steel. *Photo by Robert Vinnedge.*
Frontispiece: **A Window to the Past,** 2004, Marvin Oliver. Blown glass; 21 × 16 × 16 inches. *Private Collection. Photograph by Robert Vinnedge.*
Opposite: **Chehalis Paddles,** *detail,* 2004, Susan Point. *See fig. 22, p. 37.*

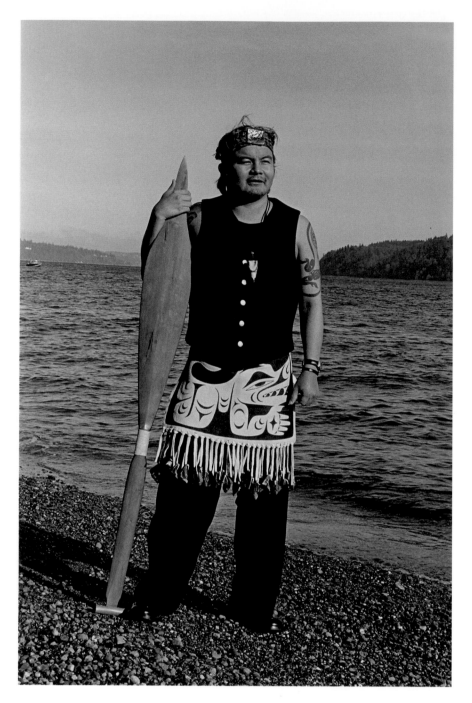

1 **Shaun Peterson,** 2003.
Photograph by Mary Randlett.

Mary Randlett has been photographing noted artists of the Pacific Northwest as well as regional landscapes since the early 1950s. This portrait of artist Shaun Peterson in his ceremonial regalia was taken on the beach near Tacoma, Washington, where his Puyallup ancestors frequently landed their canoes.

To the Stonington Gallery

2 Spindle whorl with bird image,
nineteenth century, Cowichan.
9 inches diameter. *Department of
Anthropology, Smithsonian Institu-
tion, Smithsonian National Museum
of Natural History, cat. 221179-B.
Photograph by D. E. Hurlbert.*

The bird design on this spindle
whorl is composed in what could
be called a configurative style, using
the term applied by Bill Holm to
the northern design tradition. The
bird's body outline is entirely visible,
and the body parts are in more or
less naturalistic proportions. The
design fits within the circular back-
ground, but hasn't been confined by
it or conformed to its shape. The
artist has employed rhythmic cres-
cent-and-trigon patterns to create
design movement and flow within
the bird's shape.

Thank you for inviting me to submit a few words to reflect the pride felt by
one great, great grandmother. Pride that the Puget Sound Salish culture is
also being recognized and included in the world of honored art. For many
generations our historians have kept the quiet, elegant, spiritual knowledge
of our culture and our history alive through stories and epic legends.

With an unwritten culture, our people have managed to persevere.
Now our artists continue the responsibility through their gifted talents.

*Traditionally submitted by A Great, Great Grandmother, Upper Skagit Elder,
Vi (taqwšəblu) Hilbert. Thank you for listening.*

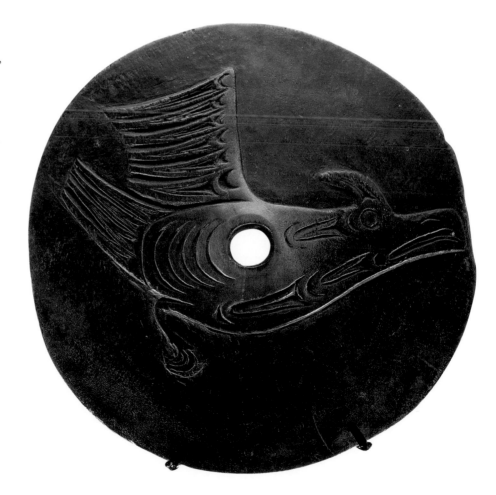

Contents

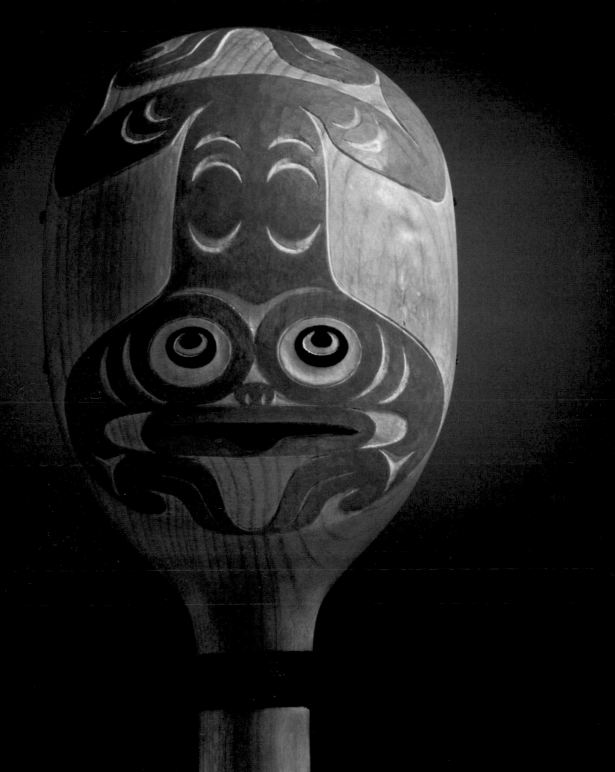

Foreword

Opposite: **Moon and Frog Rattle,**
back, 2003, Shaun Peterson. *See fig.*
36, p. 50.

IT IS AN HONOR AND A DELIGHT FOR THE
Stonington Gallery, in partnership with the University of Washing-
ton Press, to bring you the masterworks from these contemporary
Coast Salish artists. The body of work is dynamic, expressive, and
eclectic. We are encouraged and inspired by the appearance of new
media and contemporary interpretations, while the essence of tradi-
tional Coast Salish form and style has been preserved.

Our mission at the Stonington Gallery is to continue to expand and
increase awareness of and appreciation for the art, culture, and traditions
of the people of the Pacific Northwest Coast and Alaska. The exhibition
"Awakenings: A Gathering of Coast Salish Artists" provides the ideal
platform to showcase Coast Salish art in the midst of an exciting and
powerful renaissance.

Michael R. Bonsignore
STONINGTON GALLERY

Acknowledgments

Opposite: **Male House Plank,** *back,* 2004, Susan Point. *See fig. 13, p. 28.*

THERE ARE MANY PEOPLE WHOSE DEDICAtion, creativity, and knowledge combined to produce this book, a work we hope will contribute to helping all of us better understand the first art and culture of our region. Susan Point initially approached the Stonington Gallery about working together on this project. In her own career, Susan has drawn from the rich and unique legacy left to her not only by ancestors of her own region in Vancouver, British Columbia, but from the whole Coast Salish Nation—from northern Vancouver Island, the lower British Columbia mainland, and the western areas of Washington State. Our mutual involvement with public art commissions had brought to light the fact that more needs to be done to further the awareness of the aboriginal arts in the Seattle area.

To that end, the University of Washington Press joined forces with us. We thank director Pat Soden, project editor Jacqueline Ettinger, graphic designers Audrey Meyer and Ashley Saleeba, and copy editor Kerrie Maynes for helping us publish and distribute this book. Thanks to the Press for its commitment to and belief in this project.

We are grateful to Steve Brown—friend, artist, advisor, contributor, and irreplaceable co-editor. We also wish to thank contributor Barbara Brotherton, curator of Native American art at the Seattle Art Museum. Her love and knowledge of the Coast Salish people and their culture is one of our region's strongest allies in ensuring that the public will experience superb Coast Salish exhibitions and programs.

For exceptional photography we wish to thank Mary Randlett, Robert Vinnedge, and Mike Zens.

Michael Bonsignore, owner of the Stonington Gallery, has had a passion for Northwest Coast Native art for years, and his commitment to this project made it all possible. We are grateful for his support, counsel, experience, writing skills, and meticulous proofing of the manuscript. Thank you for everything, Michael.

The writing and editing of this book was due in large part to the Stonington staff's superhuman ability to multitask while we worked on this book. Mary Heagle, Leilani Norman-Young, Terry Upshall, and Chris Flanagan-Linderman, you are the best. Thank you for the care and excellence you bring to everything you do. Enormous thanks goes to our associate Jewelia Rosenbaum for her writing, editing, advice, and many late nights at the laptop. Mary Heagle's editing has been invaluable.

We honor and thank Vi Hilbert, named a "Washington Living Treasure" in 1989, who has dedicated herself to rescuing the Lushootseed language of the Puget Sound Indians from near extinction. She has collected her people's legends, stories, and personal histories and translated them into Lushootseed. Vi's beloved legends and stories about her ancestors demonstrate the values and philosophies of the Coast Salish. Many of these stories appear in her *Haboo: Native American Stories from Puget Sound*.

Susan Point worked closely with her youngest daughter, Kelly Cannell, throughout the creation of the art pieces for the exhibition and is grateful for the continued dedication of her entire Coast Salish arts family, including her husband Jeff Cannell and her other children, Rhea Guerin, and Thomas Cannell. Her friend, Vesta Giles, helped Susan to describe and translate the stories that accompany her artwork.

Thank you to the gallery's collectors, whose ongoing passion for contemporary Coast Salish art supports our efforts to promote our region's Native culture.

Finally, we acknowledge the featured artists and all of the Coast Salish artists who came before them. Thank you for your dedication and commitment to preserving this art and culture.

Opposite: **Salish Paddles,** *detail,* 2004, Susan Point. *See fig. 21, p. 36.*

Contemporary Coast Salish Art

Introduction

Opposite: **Female House Plank,** *back,* 2004, Susan Point. *See fig. 14, p. 29.*

N OCTOBER 1993 THE STONINGTON GALLERY opened "Southern Style: Contemporary Art of the Coast Salish, Makah and Nuu-chah-nulth," a major exhibit featuring the southern styles of Pacific Northwest Coast art. The goal of the exhibit was to bring the artists working in these styles to the forefront of contemporary Northwest Coast art and to further distinguish them from the more familiar and identifiable northern art traditions of the Haida, Tlingit, and Tshimshian tribes. Throughout the run of the exhibit, it became apparent that Coast Salish culture and art were comparatively unknown among visitors to the gallery, although they are the historic foundation of the Native art of western Washington and southern British Columbia.

The Coast Salish art tradition and its exquisitely rich mythology offer rewarding insights into a civilization that prospered for many thousands of years on these shores. The tribes along the Pacific Northwest Coast exemplify the ability of humanity to develop creatively when not burdened with survival. Food was plentiful, and resources for lodging and canoes seemed inexhaustible. The peoples of this region were not exempt from war or other severe challenges, but the abundance of the sea and land enabled them not only to survive but to flourish and to produce a style of artwork that has come to figure prominently among the world's artistic legacies.

Only recently have outsiders become aware of the deeper nuances of Coast Salish culture, perhaps because its history was and still is propagated orally. The tribes' cultural inheritances are passed through spoken word from storyteller to storyteller, from grandparent to grandchild, often providing explanations for the mysteries and natural phenomena of the physical

world. Coast Salish artists have made these stories and myths tangible by carving, weaving, and painting them on both everyday and ceremonial objects, thereby exemplifying the belief that objects are endowed with an intangible power that links human lives to a greater spirit world. The Coast Salish artist materializes this spirit and, along with the stories and legends, weaves the generations together, communicating the wisdom of those who have lived before to those whose time it is now.

Ceremony is a central part of the Coast Salish world. Coast Salish people have always approached their ceremonies and rituals with reverence, spirituality, and, ultimately, with secrecy. This shroud inevitably leads to limited awareness of the details of Coast Salish life and a truncated perception of the vital and sacred ceremonial art objects produced by its artists. One such ritual object that remains sacred and mysterious is the shaman's board, a tool speculated to have been used by shamans when transporting spirits between worlds. The haunting shaman's board found in the collection of the American Museum of Natural History (fig. 12) has proven a particularly important and influential icon for some of the artists presented here, such as Marvin Oliver and Susan Point.

It is clear that in the last century urbanization has created disparate environments within the traditional Coast Salish lands. Seattle, Tacoma, and Vancouver are obviously much changed from their original states of pristine forestland, a metamorphosis that is reflected in some of the artworks of indigenous artists living in these recently established cities. These urban artists have embraced the new materials that "progress" has bestowed (i.e., glass, concrete, and steel) and have integrated ancient images with modern materials their ancestors could not have envisioned. Today's prominent Coast Salish artists show great versatility in their execution of the traditional art form using contemporary materials, which speaks to their persistent creativity in spite of the profound changes affecting their tribal lands.

In the decade since our 1993 exhibition, we have watched as increasing numbers of Coast Salish artists have immersed themselves in their histories and traditions. By working with elders and scholars, accessing museum archives, and seeking out and connecting with those who share the same vision, they have gained extensive knowledge about their languages, rituals, ceremonies, songs, and the stories that shaped the lives of past generations. The momentum in contemporary Coast Salish art and the incredible growth and development that have taken place in this field have led to the emergence of one of the most dynamic and meaningful aboriginal art forms in North America, one that competes successfully with the most elegant and sophisticated contemporary arts of our time.

Each artist shown here is at the forefront of his or her tribe's cultural man-

ifestation and identity. Through their art, these artists revitalize their ancestral past while giving nontribal persons an appreciation for the civilizations that preceded them in this region. Art plays a critical role in the development of society and it is the artist's indelible drive that keeps this culture alive and flourishing.

Thankfully, the artistic imprint that the Coast Salish people left behind is still visible and growing clearer by the day. This book and the "Awakenings" exhibit are an acknowledgment of the men, women, and children who for thousands of years prospered with the plentiful resources native to the Pacific Northwest Coast. It is also a celebration of the vivid intelligence, dedication, and creative spark of today's Coast Salish artists who are carrying their traditions into the future.

Rebecca Blanchard and Nancy Davenport
DIRECTORS, STONINGTON GALLERY

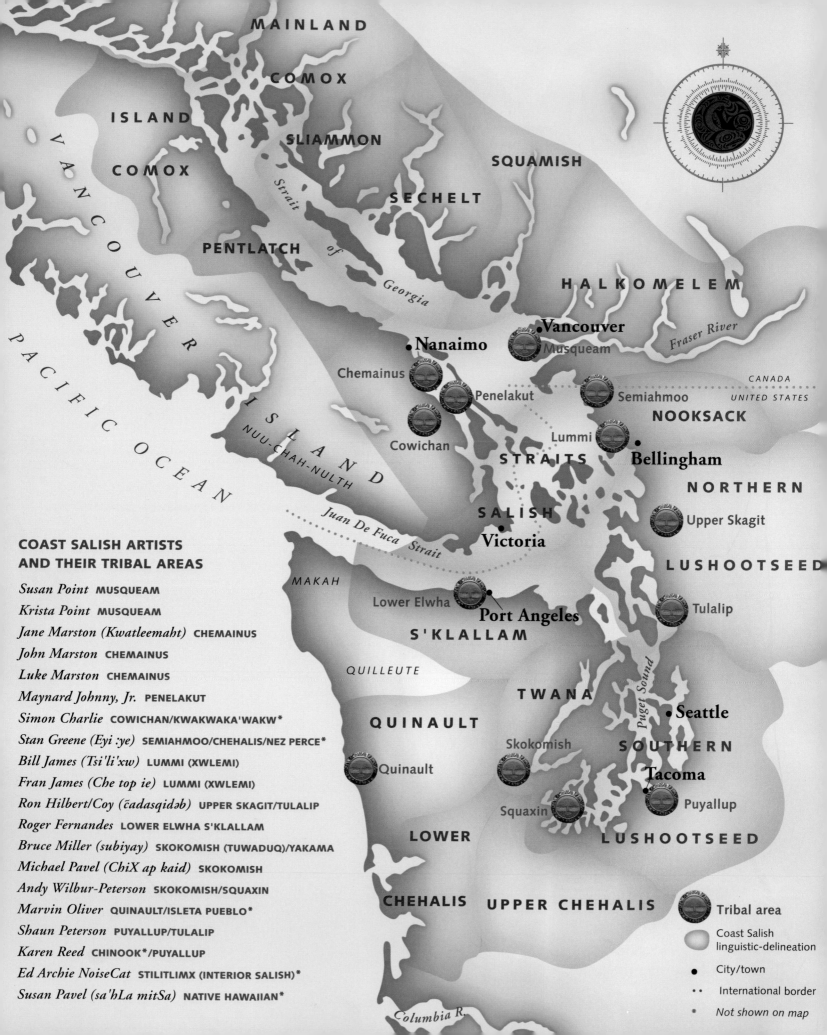

MAINLAND

COMOX

ISLAND

SLIAMMON

COMOX

SQUAMISH

SECHELT

Strait

PENTLATCH

of

Georgia

HALKOMELEM

VANCOUVER

•Vancouver

Fraser River

Nanaimo

Musqueam

Chemainus

CANADA

Penelakut

Semiahmoo

UNITED STATES

ISLAND

NUU-CHAH-NULTH

Cowichan

Lummi

NOOKSACK

STRAITS

Bellingham

PACIFIC OCEAN

SALISH

NORTHERN

Victoria

Upper Skagit

Juan De Fuca Strait

LUSHOOTSEED

MAKAH

Lower Elwha

Tulalip

Port Angeles

S'KLALLAM

**COAST SALISH ARTISTS
AND THEIR TRIBAL AREAS**

QUILLEUTE

Susan Point MUSQUEAM

Krista Point MUSQUEAM

TWANA

Puget Sound

Jane Marston (Kwatleemaht) CHEMAINUS

QUINAULT

•Seattle

John Marston CHEMAINUS

Luke Marston CHEMAINUS

Skokomish

SOUTHERN

Maynard Johnny, Jr. PENELAKUT

Simon Charlie COWICHAN/KWAKWAKA'WAKW *

Quinault

Tacoma

Stan Greene (Eyi :ye) SEMIAHMOO/CHEHALIS/NEZ PERCE *

Puyallup

Bill James (Tsi'li'xw) LUMMI (XWLEMI)

Fran James (Che top ie) LUMMI (XWLEMI)

Squaxin

Ron Hilbert/Coy (c̄adasqidəb) UPPER SKAGIT/TULALIP

LOWER

LUSHOOTSEED

Roger Fernandes LOWER ELWHA S'KLALLAM

Bruce Miller (subiyay) SKOKOMISH (TUWADUQ)/YAKAMA

Michael Pavel (ChiX ap kaid) SKOKOMISH

Andy Wilbur-Peterson SKOKOMISH/SQUAXIN

CHEHALIS

UPPER CHEHALIS

Marvin Oliver QUINAULT/ISLETA PUEBLO *

Tribal area

Shaun Peterson PUYALLUP/TULALIP

Karen Reed CHINOOK*/PUYALLUP

Coast Salish
linguistic-delineation

Ed Archie NoiseCat STILITLIMX (INTERIOR SALISH) *

• City/town

Susan Pavel (sa'hLa mitSa) NATIVE HAWAIIAN *

•• International border

Columbia R.

* Not shown on map

The Coast Salish Two-Dimensional Art Style: An Examination

LTHOUGH THE VISUAL ART OF THE
Northwest Coast is sometimes perceived as a homogenous
phenomenon across the entire coastal geographic range
from Puget Sound to Southeast Alaska, it is actually made
up of many regional styles. Some of these design styles
differ greatly from one another in composition and application. The Coast
Salish two-dimensional art style is found on the southern end of what is
commonly defined as the Northwest Coast culture area. In its most south-
ern extreme, the Coast Salish design style is found from the Puget Sound
area south-westward to the coast. In varying form it extends northward up
the Strait of Georgia as far as Desolation Sound. The Coast Salish language
family as a whole comprises one of the largest populations and geographic
ranges of any on the Northwest Coast, and includes within it a large num-
ber of related but different linguistic groups. Among these are the Pentlatch
and Comox in the northern end of the region, the Halkomelem and Straits
Salish in the central area, and the Lushootseed and Xwulshootseed of north-
ern and southern Puget Sound, respectively.

Between the ethnic groups of the northern Northwest Coast region
(defined as southeast Alaska and northern British Columbia) and the Coast
Salish peoples of the southern Northwest Coast (southern British Colum-
bia and Washington State) are found the Nuu-chah-nulth, Makah, Kwak-
waka'wakw, and Oowekeno First Peoples of central British Columbia,
whose design traditions are sometimes referred to as the mid-coastal style.
Each of these groups has synthesized a very free-form and flamboyant
two-dimensional style that defies direct comparison to the northern design

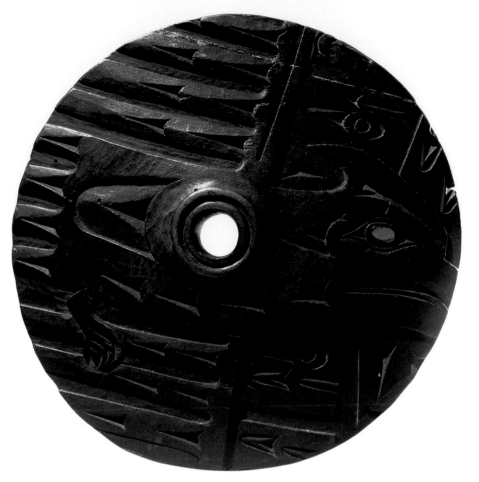

3 **Spindle whorl with bird image,**
nineteenth century, Halkomelem.
9 inches diameter. © *The Field
Museum, A108064c. Courtesy Field
Museum of Natural History, Chicago.
Photograph by Ron Testa.*

The bird in this composition is rendered in a manner that could be described by Holm's term "distributive." The artist has depicted the bird so that it completely fills the circular form of the spindle whorl, and has even placed negative design elements in the few background areas that remain behind the bird image. The trigon forms surrounded by carved out U-shaped areas in this design show a remarkable similarity to the form and proportion of northern-style negative U-shapes, and give a suggestion of their historical development. Rhythmic rows of design elements create movement patterns within the composition, as in figure 2.

conventions and shows only an elemental relationship to the southern or Coast Salish design traditions to which each is, however, clearly related.

Where, one may ask, did all of these vastly differing yet related regional design traditions originate? Are they all branches of one ancestral tree, with a common root, or did they develop independently, gaining similarity by mutual influence over time? The answers to these questions are not definitively known, but a certain amount of archaeological evidence supports the common root theory (Brown, 1998). Examples of the southern or Coast Salish style as it was known in the historical period (from 1775 to the present) have been found that date back 3,000 to 4,000 years. In the northern coastal region, examples of design traditions related to the northern style have been found that date back 1,000 to 2,000 years (Carlson, 1983: 203). These design compositions, not fully developed into the classic historical-period northern art form, have been termed proto–Northwest Coast style (Brown, 1998: 7).

In the northern as well as the southern region, examples of basketry that incorporate historic-period materials and techniques have been recovered that, in some cases, date back 5,500 years. Artifacts of less perishable materials, such as bone and stone, indicate that human occupation during the current postglacial geographic distribution of land and water on the Northwest

4 Spindle whorl with man and fish images, nineteenth century, Halkomelem. 8 1/2 inches diameter. *© The Field Museum, A108066c. Courtesy Field Museum of Natural History, Chicago. Photograph by Ron Testa.*

This composition illustrates how Coast Salish artists sometimes blended multiple figures in the same design space without defining borders between the images. The man and the fish occupy the same space here, each being depicted as part of the other. This kind of visual pun is also seen in some designs of the northern tradition, but in a less subtle manner, with more definition of the individual images.

Coast dates back to somewhere between 9,000 and 12,000 years before the present time. Undoubtedly, objects were being decorated throughout the intervening years between 12,000 and 2,000 BP, but the design styles of the earliest millennia appear very different from those that evolved into the historical period. Artifacts incised with geometric lines and patterns predate those with curvilinear designs in the historic period styles.

Surprisingly, the 1,000–2,000-year-old objects from the northern region recovered to date appear much more similar in style to the southern or Coast Salish design traditions than they do to the northern design conventions of the historical period (Brown, 1998: 9). The 3,000–4,000-year-old artifacts from the Coast Salish area bear a great deal in common with historic period objects from that region, and remained essentially unchanged over that period of time (Carlson, 1983: 203). Bill Holm briefly assessed the evolutionary position of Central Coast Salish style in this way: "I see Georgia Strait Salish art as related to other southern coastal arts—Nootka art, things from the Columbia River, etc. I see them all as a development, an extension, of a widespread, basic art expression [that] ultimately lay behind both [Salish] art and northern art. [Coast Salish] art may actually be closer—this is really conjecture, there's lots of missing links—but [Coast Salish style] may be closer to that earlier, widespread, tradition" (Holm and Reid, 1975:

9

Simple elegance characterizes this
design, in which crescent and trigon
forms are sparely used to indicate
the feathers of the bird's wing. The
protruding wing in the center creates
the handle or grip area of this tool
used in the making of cattail rush
mats.

58). That "earlier, widespread tradition" is what this writer has termed proto–
Northwest Coast art (Brown, 1998: 7).

Can one deduce from this that the northern style evolved in the last 2,000
years from the core design conventions of the southern style? Perhaps not.
The interpretive power of the archaeological evidence is limited, of course,
by the relatively small amount of material that has been recovered. It could
be, however, that over a thousand years ago a design tradition that can be
called proto–Northwest Coast style developed somewhere on the coast, and
became widely distributed from one end of the area to the other. In the
northern region, that elemental style evolved in distinctive ways that empha-
sized the standardization of positive design fields, which surround the carved
out or negative design areas, into particularly proportioned lines and shapes.
Over time these became the "calligraphic" painted lines for which Bill Holm
coined the term "formline" in his well-known study *Northwest Coast Indian
Art: An Analysis of Form* (Holm, 1965). Formlines are the network of painted
lines (in black or red) that change so dramatically in thickness as they form
harmonious movements within any design field or creative representation.

Holm's well-respected book does an exemplary job of analyzing and
revealing the conceptually layered structure of the nineteenth-century
northern design style, its highly conventionalized use of color, and many
of its compositional consistencies. As a result, the interested public and an
entire generation of Native and non-Native artists became familiar with the
conventions of northern-style work from this period. Holm's book served as
a sort of "Rosetta Stone," and helped to foster the revitalization of North-
west Coast Native art that began around 1960 and continues today. In the
early part of this timeframe, the nineteenth-century northern or "classic"
style became the standard against which all Northwest Coast art, from any
region or time period, was appraised. One unfortunate down-side of this
was that non-northern art traditions became somewhat marginalized, and

6 Spindle whorl with legged serpent, early style (c. 1800), Cowichan. 8 1/2 inches diameter. *Courtesy Burke Museum. © Department of Anthropology, Smithsonian Institution, cat. 221179-E. Photograph by Bill Holm.*

The unusual mythical creature depicted in this spindle whorl appears to be much earlier in style than the other examples illustrated here. This design seems to have as much in common with decorated objects from Ozette village (said to be 300 to 500 years old) as with the other designs seen here. The simple outline alone sets the creature apart from the background, and incised negative shapes have been only sparsely applied. The very simple eye form, the archaic character of the outline of the image, and the single rhythmic line of embellishment suggest that this design was created many decades if not generations before the object was collected in 1913.

were viewed by some as less sophisticated versions of the northern style—an unfair assessment that they truly do not deserve.

The southern coastal traditions were sometimes even derided as "degenerate" northern style. The structural and compositional differences that distinguish Nuu-chah-nulth and Coast Salish styles from the northern traditions were seen as steps backward from the more formal, evolved structure of the northern art system instead of divergent evolutionary movements from a universal original source. Coast Salish artists led by Rod Modeste, Stan Greene, and Susan Point began to look toward the ideas and design principles embedded within the best old central Coast Salish works from the area of southern British Columbia in which they live. Even before these younger artists came to the forefront, an older generation of Coast Salish artists, such as Simon Charlie, Cicero August, and others, worked in and maintained a mid-twentieth-century Coast Salish style, albeit one infused with their own interpretations of the tradition. These carvers have been instrumental, however, in passing on ideas and techniques to the younger generations of artists.

On the U.S. side of the international boundary, Marvin Oliver, whose father is Quinault, began his Northwest Coast–style work in the northern tradition, but later redirected his attention to producing Coast Salish–style

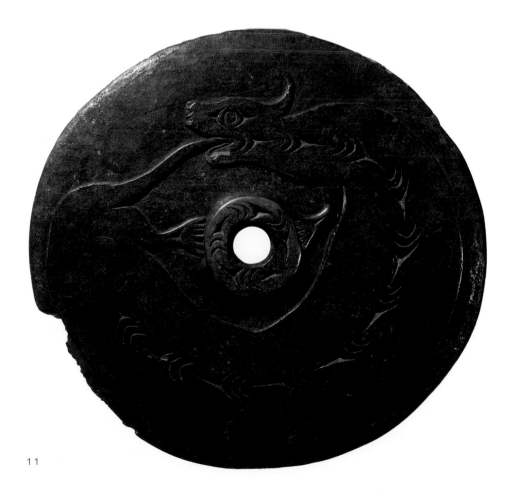

work in a variety of media, including cast glass and bronze. One of the first Northwest Coast and certainly Coast Salish artists to branch out into alternative media, Oliver has created glass and bronze works for public art projects and private commissions (see figs. 33 and 34). These and other artists of this early contemporary period, including non-Native Duane Pasco, helped to bring Coast Salish style out of the dark corners of museums where it had long hidden, and to illuminate its artistic qualities.

Characteristics of the Coast Salish Art Style

The proto–Northwest Coast tradition is built on a relatively small number of design elements that make up the majority of the carved-out portions of any given composition: incised circles and ovals, crescents, and the characteristic triangular forms with inward-curving sides known as trigons (see ills. 1a, 1b, 1c). The interplay of these core shapes (which form the negative elements) and the surrounding surface areas (which make up the positive design forms) creates the essential design system from which both the southern (including mid-coastal) and northern design traditions appear to have evolved.

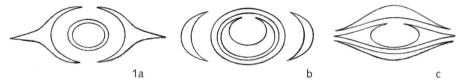

1a b c

1a, 1b, and 1c. **Eye forms** composed using circles, ovals, crescents, and trigons. *Drawings by Shaun Peterson.*

In the case of the southern traditions, specifically the Nuu-chah-nulth and Coast Salish, the essence of the proto–Northwest Coast design system appears to have changed very little up through the very early historic period. In the early nineteenth century, Nuu-chah-nulth style began to diverge from its root source, developing as a painter's tradition into something quite different and distinct from Coast Salish style. The Coast Salish two-dimensional arts remained more conservative, and survived reasonably intact through the end of the nineteenth century. Vestigial forms of the proto–Northwest Coast style can readily be seen in the northern design tradition as well, most obviously as the "transitional devices" described by Holm: the negative circle, crescent, and trigon (although in Holm's terms the trigons are referred to as "T-shaped reliefs"). Further, the negative spaces within the formline U-shapes of the northern style are readily seen as widened trigons or deepened crescents. The hollowed eye socket surrounded by an ovoid formline in the northern style can be seen to branch from the practice of carving negative areas outside of and parallel to the eyelid lines in the proto–Northwest Coast and historic Coast Salish traditions (see ill. 1c).

From a practical point of view, the wise northern-style design composer

2a, 2b, and 2c. **Animal head profiles** in the Coast Salish design style. *Drawings by Shaun Peterson.*

Each of these animal images incorporates ovals, crescents, and trigons in order to define physical features such as eyes, nostrils, etc., and to refine and direct the flow of design movement within the composition.

will recognize the primary and essential part played by the negative aspects of formline style—the inside edges of and area surrounded by formline ovoids, U-shapes, and other painted elements. What has driven the design system since its infancy still works to advantage in composing original images today.

Coast Salish–style two-dimensional designers also compose from the negative side out, as did their proto–Northwest Coast predecessors. The placement of negative elements creates the definition and flow of the imagery. One of the major differences between Coast Salish and northern styles, however, is that in the Coast Salish style, the positive design areas that result from the placement of negative shapes do not take on the kinds of consistent proportional characteristics that define northern-style formlines. Formlines, as defined by the northern style and described by Holm, simply don't exist in the Coast Salish design tradition, though some writers on the subject have attempted to apply the term. There does exist a continuous "net" of positive design field, pierced in flowing patterns by the negative elements, but it does not possess the consistent types of conventionalized design shapes that are so characteristic of northern-style work, and for which the term "formline" was created.

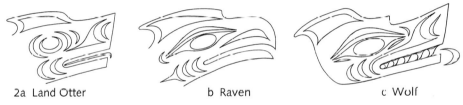

2a Land Otter b Raven c Wolf

The negative or carved-out design elements in Coast Salish style can be used to define various physical parts of creatures, such as eyes, nostrils, etc. (see ills. 2a, 2b, 2c). Crescents and trigons in particular are employed to define the connections or boundaries between parts, what could be called the "points of transition." Examples of such use include the placement of a trigon at the base of an ear (as seen in ills. 2a, 2b, and 2c and figs. 2, 3, and 8) or at the wrist joint at the base of a hand or foot (figs. 6 and 8). A crescent or trigon also commonly appears at the back of a mouth slit, demarcating the line between a bird's beak and the edge of its feathered skin, or to imitate the fold of skin where a human's or animal's mouth meets the bulge of its cheek (figs. 2–8). Crescents and trigons are also used to build lines or rows of rhythmic, repeating elements that are used to create patterns of movement, lending a sense of detail and dynamic flow to the interior of a composition (figs. 2, 3 and 5–8).

As can be seen in the illustrations of spindle whorls, a mat creaser, and a horn rattle, the negative elements (including the carved-away surface of the background areas) leaves the positive design areas raised on one or more

13

levels above the surface of the background. In the case of the spiral creature on the spindle whorl in figure 6, the paucity of negative forms leaves a large and broad positive area that makes up the sausage-like body of the creature. This example shows most readily how the concept of positive formlines does not directly apply to Coast Salish design. The area surrounding the carved-out negative crescents and trigons is completely undefined until it reaches the creature's outline. Other examples contain a more equal balance between positive and negative space, as seen in figures 2–5, 7, and 8. Here one is tempted to see the positive areas as having formline-like qualities, but the resultant positive forms are not at all like the consistent, conventionalized shapes (ovoids, U-shapes, etc.) found in all works of the classic northern style. The northern-style artist can readily compose designs by painting the positive formlines around the negative areas that will eventually be carved out. A southern or Coast Salish–style artist would be very unlikely to do this, as the positive areas are actually the resultant forms created by the place-ment of negative elements, and do not function in the process of composi-tion as do the northern formlines. An example of this can also be seen in the bird image in figure 3, which contains two large negative U-shapes that are remarkably like those commonly seen in northern-style design. The positive area around them, however, is not confined or defined in the same way that it would be in the northern tradition, where a black or red formline U-shape would be used to surround the negative forms.

A number of compositional techniques are common to both the north-ern and Coast Salish two-dimensional traditions. These compositional traits, presumably conceived in the proto–Northwest Coast art period and evolved in the divergent directions taken by northern, mid-coastal, and Coast Salish

8 Spindle whorl with human and flanking birds, nineteenth century, Halkomelem. 9 inches diameter. *Courtesy Burke Museum. © A. de Menil, New York. Photograph by Bill Holm.*

Certainly one of if not the most highly developed spindle whorl designs in existence, this image has served as inspiration for many practitioners of Coast Salish design. The two flanking thunderbirds overlap and blend with the human figure at the center of the design field, and the human faces in the circles within the birds' bodies are in deeply carved relief. Foreshortened wings extend out to the edge of the surface, dwarfed by the body forms. The human figure's hands converge at the center hole, where the spindle shaft would pierce the whorl. It's at this point, say Coast Salish shamans, that spirit power enters and leaves the body. The small two-dimensional image inside an oval in the man's body may represent a spirit helper who dwells within.

artists with their respective styles, remain as a pan-coastal underlayment within the overall Northwest Coast art tradition. These traits include compositional preferences of the northern art style described by Holm as "configurative" and "distributive" (1965: 12, 13). A configurative design is one in which the outline of a creature and the proportions of its body parts are more or less in their natural form. Such a design is not contorted to adapt to the shape of the design field in which it appears. A distributive design, in contrast, subordinate's a creatures natural body shape and proportion in order to adapt to the shape of the design field where it is depicted completely filling the space. In between these two conceptual extremes lies a broad range of design compositions that Holm has termed "expansive." These compositions fall somewhere between configurative and distributive in terms of their degree of adaptation of a creature's natural form to the shape of the design field. Configurative and distributive Coast Salish compositions are illustrated in figures 2 and 3, respectively. Another trait common to the entire coast is the use of mask-like faces within large joint centers such as wings or tails, as seen in figure 8. The use of visual puns, in which a given design space is occupied by more than one creature (sometimes indicative of transformation) is another, illustrated in figures 4, 5, and 8.

Compositional differences, though, to a large extent distinguish northern-style design from the images found incised into objects on the southern

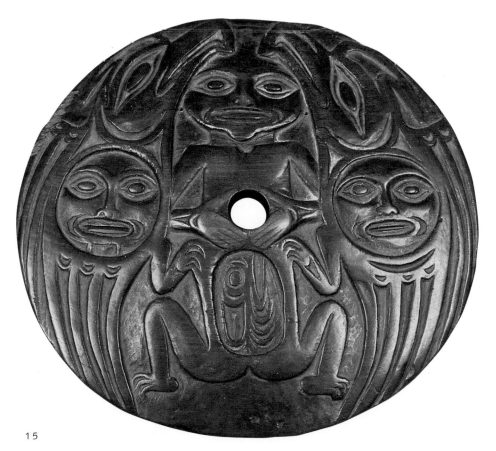

15

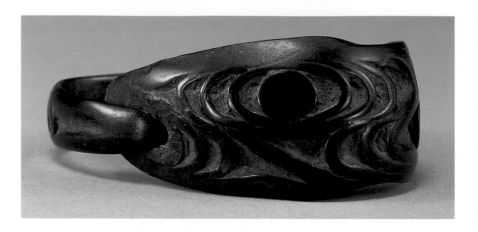

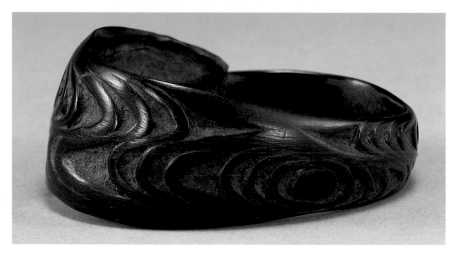

At one time in history, Coast Salish goat horn bracelets were sometimes misidentified in museum collections as being from New Guinea, due to the similarity of their incised designs to those on masks and other objects from that area of the southwest Pacific. The material, however, is native only to North America. Very few of these intriguing bracelets have been acquired by the world's museums, and those that have been documented were all collected very early in the historical period, suggesting that their production ceased in the early nineteenth century. The variety of patterns on the surviving examples shows the range of expression that is possible within this simple yet powerful design style.

Northwest Coast. When a bird is represented in Coast Salish style, for example, in most cases the wing feathers are depicted as single rows of design elements flowing from the wing's generally straight leading edge. Each line of feathers is punctuated along its length by crescents or trigons (see figs. 2, 3, 8, and 34). This treatment also frequently appears in mid-coastal Nuu-chah-nulth and Kwakwaka'wakw design work, commonly with the addition of color in a rhythmic pattern (Nuu-chah-nulth) or further design element elaboration (Kwakwaka'wakw). The northern artist would generally not conceive a wing design in the same way, preferring instead to represent the layering of feathers in a bird's wing by composing different-sized ovoids, U-shapes, and secondary design elements in a pattern incorporating various levels of detail.

Another difference between these two traditions can be seen in the northern propensity for employing ovoids as design "centers" in wings, legs, or tails, which is not universally replicated in historic Coast Salish design work. Figures 2, 3, and 5 do not employ this trait, although figure 8 includes the round faces in the body of the birds that flank the central human figure. This approach to composition, however, does appear in its own fashion in

the work of many historic Kwakwaka'wakw artists—even those with little evidence of the northern design conventions apparent in their style.

Contemporary Coast Salish Two-Dimensional Design

The inventive revitalization of Coast Salish design that has taken place in the last twenty-five years has been a great joy to experience. A handful of determined and creative Coast Salish artists have brought back the best of the old historic design styles and expanded upon them to create wholly new works. This new Coast Salish art has expanded the traditional art conventions in terms of such features as color use, media, and function or application.

Marvin Oliver of Seattle was one of the first Northwest Coast artists to experiment with the design and production of artworks in contemporary media. Some of his work was executed in the northern style, such as a blown-glass Tlingit-style warrior's helmet, but Oliver has also produced several bronze and glass castings in the Coast Salish design style. Oliver's first glass castings were incorporated into his work entitled *Transition II* (see fig. 33).

Oliver's largest cast bronze work is the twenty-six-foot-tall dorsal fin *Spirit of Our Youth,* which stands on the grounds of Remington Court Park (near 13th Avenue East and East Remington Street) in Seattle (see fig. 34). The designs on this monumental sculpture incorporate Coast Salish two-dimensional style and geometric patterns related to the chip-carved designs of many historic southern Coast Salish sculptures, such as the rims of wooden bowls. These patterns are also reminiscent of the geometric designs woven into basketry containers and woolen blankets created by Coast Salish women. Marvin Oliver's work in Coast Salish style also includes three- to seven-foot-tall cast glass and bronze dorsal fin sculptures that join a long list of projects that have been created as public art in Seattle and around western Washington. Oliver has also produced many serigraphs, largely in the northern style, incorporating additional techniques such as highly detailed embossing.

Coast Salish artist Susan Point from Musqueam (at the mouth of the Fraser River) has produced a great deal of work that successfully explores many contemporary treatments of traditional design. Her wood-block prints and serigraphs have brought historical Coast Salish images to a new audience and have crossed many traditional barriers with respect to media and production scale. Her major public art installations and architectural artworks have expanded the applications of traditional art. Point's designs can be seen in many cast steel tree gratings about the city of Seattle, and her cast-concrete architectural works embellish public buildings in Seattle and

in the capital of Washington State, Olympia. A seventeen-foot-diameter wooden spindle whorl graces the international arrivals terminal at the Vancouver International Airport, along with two large welcome figures carved in massive red cedar. A large human figure and two high-relief house posts are installed on the grounds of the University of British Columbia Museum of Anthropology, all based on historical Musqueam carvings. Not far away, at the First Nations House of Learning on the University of British Columbia campus, a massive house post produced by Point supports one of the roof beams of the building. The architectural form of the House of Learning incorporates traditional features of both Coast Salish and Northern Coast houses, a testament to how historical and modern structural systems can work together in a very attractive and functional building.

Among Point's work for the exhibition associated with this volume is a relief-carved wooden panel entitled *Northwind's Fishing Weir* (see fig. 23). One of her Seattle public art projects, *Northwind's Fishing Weir* (installed in a small park near the Duwamish waterway) dealt with a similar concept in a different manner and medium. In this two-dimensional work in wood, several traditional Coast Salish design elements have been melded into the presentation. The interlocking-triangle or chip-carved zigzag design seen on some southern Coast Salish objects and basketry patterns appears here as a metaphor for a meandering river. The sophisticated use of U-shapes in the border designs echoes the ancient pattern. The gracefully interlocking mirror-image fish designs within the river are depicted in classic Coast Salish style, but with the added elegance of M. C. Escher–like patterning that can be seen as a metaphor for the interrelationships of river habitats and salmon in hatching and spawning cycles.

Point's *Water—The Essence of Life* (see fig. 11), a complex set of repeating panels, is closely related to the monumental architectural work she created in 1993 for the West Seattle pump station on Harbor Avenue Southwest, which is topped by a huge frieze made up of repeating and adjoining panels running the length of the building. Cast in concrete as manageable individual squares, the 1993 frieze evokes images of infinity as it rhythmically encompasses the building.

Shaun Peterson, of the Puyallup First Nation, is a younger artist who has brought his artwork to a level that has gained appreciation from an ever-growing audience. Peterson has completed a number of municipal commissions that can be seen in Tacoma, which has been much more supportive of Native arts as public enhancement than has its larger neighbor, Seattle. Of all the Coast Salish artists working today, Peterson has one of the best-developed facilities with historical Coast Salish design. He has absorbed the inner workings and concepts of Coast Salish masterpieces and has learned to

10 **Wolf,** 2000, Shaun Peterson.
Acrylic on canvas; 126 × 52 inches.
*Private collection. Photograph by Steve
Brown.*

Peterson's wolf painting employs the
direct, positive-and-negative contrast
that is inherent in the ancient Coast
Salish tradition to powerful effect.
The wolf is compactly and comfort-
ably arranged in the narrow rectan-
gular space, its body parts composed
to flow effortlessly back and forth
across the design field. The character
of this composition expertly captures
the essence of the ancient Coast Sal-
ish tradition.

apply these to his original design work in a way that consistently reflects the idiosyncrasies and stylistic nuances that make Coast Salish style what it is. Peterson can create a completely original composition of human and animal images that looks as though it were designed by one of the best of the historic Coast Salish artists, without "leaning on" existing historical compositions as an armature on which to base its success.

Peterson's large painted canvas entitled *Wolf* (fig. 10) exhibits his facility with classic Coast Salish style. The sinuous wolf reposes in a narrow corridor between two border designs of repeating eyes, reminiscent of the blade patterns on some historical whalebone clubs, on objects from the ancient Makah village of Ozette, and in some historical Coast Salish works. His elegant use of rhythmic crescent-and-trigon patterns fills the form of the wolf and lends it a harmonious flow. The relationship of these patterns to the movements of wind and water have been observed by Northwest Coast art enthusiasts who travel by boat (Raban, 1999). Peterson's *Moon and Frog Rattle* (fig. 36) combines the simple sculptural forms of Coast Salish style with abalone-inlaid circle-and-crescent patterns that suggest latent energy forms, such as those often encountered on historical Coast Salish goat horn bracelets and other artifacts.

Contemporary Coast Salish works have been emerging from the hands of many additional artists of Canada and the United States, including the well-known Stan Greene, Manuel Salazar, Maynard Johnny, Jr., Joseph Wilson, and Andy Wilbur-Peterson. The innumerable painted drums, serigraphs, and sculptures that these and the above artists have produced reflect the depth and history of the ancient Coast Salish style, and demonstrate the complexity and inherent harmony characteristic of all the Northwest Coast Native art styles. Coast Salish art has come out of the shadows, and its emergence has expanded and multiplied the resilient branches on the ever-growing Northwest Coast family tree. The artistic conventions laid down by generations of ancient practitioners are in good hands among the artists of today, and their work brings the beauty and historic magnitude of this style to all of us.

Steven C. Brown
INDEPENDENT RESEARCHER AND ARTIST
OCTOBER 2004

ʔadᶻalus s'abatəb
"Something Beautiful to Give"

RECENTLY, AT A GATHERING OF THE NORTH-west Native Basketry Association, Upper Skagit elder Vi (taqʷšəblu) Hilbert gave the invocation by sharing a teaching inspired by the resilience of the cedar tree: "You might bend, but you will not break." She acknowledged that the life of an artist is not an easy one, but rather one that requires vigilance, determination, experimentation, patience, and a strong mind. Because the artist calls upon the spirit realm for guidance (*k̓ʷədīcut*), and because the artist must become intimate with the natural world the Creator has left for us, it is a blessed gift to be an artist.

Two hundred years ago the ancestors of today's Salish artists were carving monumental cedar house posts with images that made reference to the social and religious status of the family who lived within the house—their mythic beginnings, ancestral histories, spirit associations, and ritual privileges. Ceremonial regalia—masks, rattles, staffs, and other forms—were visual manifestations of ideological and cosmological beliefs. At the same time, Salish women who specialized in the weaving of baskets and robes were transforming roots, grasses, bark, and mountain goat wool into items of breathtaking richness and tangible wealth. The weavers' skills and originality provided garments that protected new dance initiates, that formed marriage dowries for the high class, and that provided surplus wealth for potlatch hosts to give as gifts, thus enlarging the family's prestige for the duration of their lives and beyond.

There is no word for "art" in the Salish language, but the Lushootseed word *x̌al* (to mark) expresses making a mark, of altering, changing, or transforming what merely exists into something of sublime beauty and meaning.

21

Some artists have said that the impetus "to make a mark" comes from the spirit and that they have to keep an open door to what the spirit wants them to share with the world. That is not to say that artists are merely agents of a higher power; their own ingenuity can be felt in the form of the work, in its contours, colors, designs, and its overall expressive power.

Carvings and weavings were not experienced on their own, but were part of an ordered and comprehensive cultural totality, with enmeshed political, social, economic, and spiritual aspects. Visual arts were but one part of a web of creative expression that also included oratory, dancing, singing, and drama. One can certainly lament what has changed, and indeed been lost, within the last two hundred years. Yet the work of these artists does more than defy the notion that Salish art is of the past, that it is located in the recesses of museum storage, and that it is less tutored than other art styles. Rather, the individual achievements and collective potency of the artists shown here are testaments to the teachings of the cedar— "You might bend, but you will not break." If the arts of the past can be thought of as the stalwart supporting trunk, then the arts of the present are the new foliage that rise towards the sky, with grace and surety. The recent revivals of language, storytelling, canoe-making, carving, weaving, printmaking, and glasswork signal that it is time for educational institutions, art galleries, and museums to take notice of what these expressive arts contribute to Native and First Nations communities, and to the world at large.

Barbara Brotherton
CURATOR OF NATIVE AMERICAN ART
SEATTLE ART MUSEUM

Susan A. Point
MUSQUEAM

Marvin Oliver
QUINAULT/ISLETA PUEBLO

Urban Innovators

LIFETIMES BOUND TO NATURE HAVE HONED IN the Coast Salish peoples an acute sense of the rhythms of the land. Coast Salish artists of the past created their work exclusively from indigenous and later traded materials. During the last century, their land has endured tremendous transformation demanding an equivalent revision of these time-honored ways. Skyscraper forests now stand where ancient cedars once blanketed the ground. While the outlying areas and islands of the Puget Sound still hold unbroken land, the urban cores of Seattle and Tacoma, Washington, and Vancouver, British Columbia, have changed forever. With the urban development of tribal lands, their environment is no longer an inexhaustible resource for materials, yet through this environmental and cultural upheaval, some wonderful new ideas and adaptations have taken place in the Coast Salish art community. Artists are by nature resourceful, creative, and adaptable, and these artists, aware of the decline of old growth cedar forests, understand the importance of marrying their established culture with new methods and visions. As city dwellers, artists such as Marvin Oliver and Susan Point draw inspiration from Coast Salish traditions, rituals, and values, as well as from the modern aesthetics and materials that their urban environments afford.

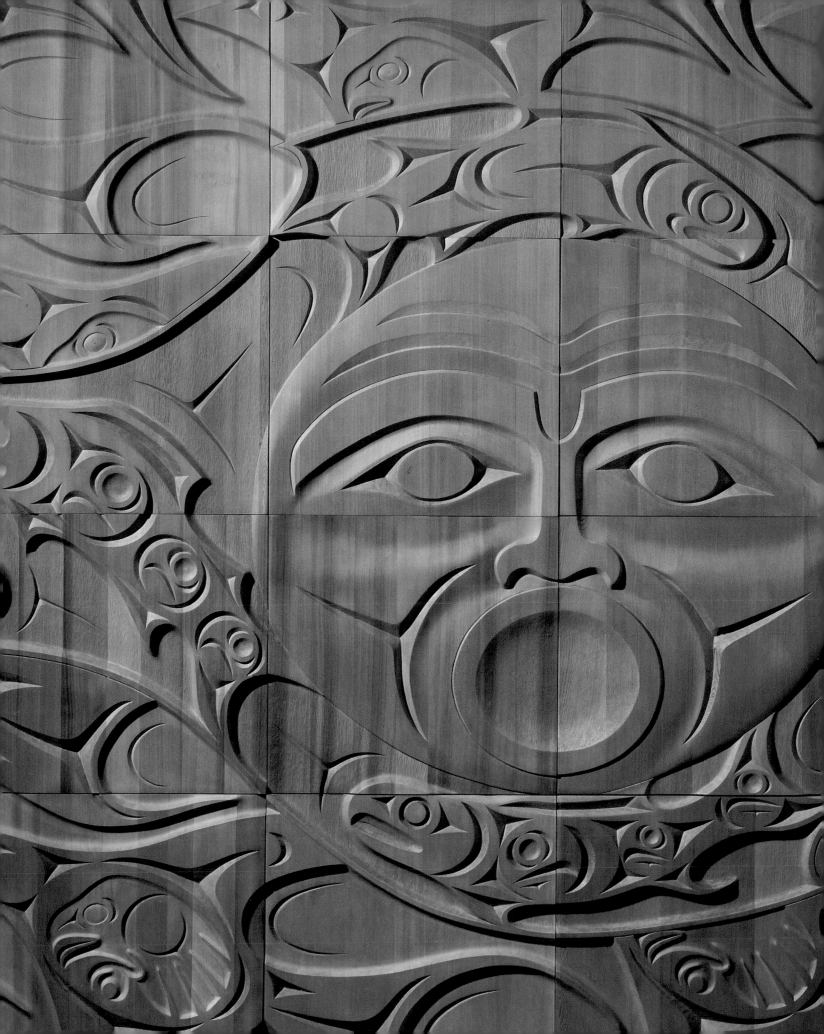

Susan A. Point

The art of Musqueam artist Susan Point (b.1952) reflects the dual influences of growing up in a traditional Salish home on the Musqueam reservation while also being within one of the West Coast's most cosmopolitan cities— Vancouver, British Columbia. Point's familiarity with and love for the rivers and mountains of her homeland combine with the rich ceremony of her Musqueam culture to imbue her art with centuries of ancient Coast Salish history. Through her work, Point pays tribute to her family, who has taught her so much about her heritage. Her late mother, Edna Grant-Point, taught her the values and traditions inherent to her culture and encouraged her to pursue her career as an artist. Her late uncle, Dominic Point, another extremely important figure in her life, taught her the stories and history of her people. Inspired by these mentors, she has studied traditional Coast Salish art and has emerged with a visual language both historically authentic and vibrantly contemporary. Her carvings incorporate the patterns that traditional Coast Salish artisans and weavers employed, yet her immersion in contemporary urban life often inspires her to celebrate these images in nontraditional materials. Point's work in blown and cast glass, developed during her artist-in-residency at the Pilchuck Glass School in Stanwood, Washington, exemplifies the blending of ancient and modern, and offers a new aesthetic that contributes another dimension to Coast Salish art. Her drive for new challenges, willingness to work with new material, and vision for the monumental have made Susan Point a prominent artist for both public and private commissions.

Water—The Essence of Life (fig. 11) began as the original cedar carving for reproduction into concrete for the Municipality of Metropolitan Seattle's West Seattle pump station. Because the piece was intended to be concrete tiles for the façade of the building on Harbor Avenue Southwest, Point had boldly but sparingly worked the initial carving to assure a clean reproduction of the imagery. After molds were taken of the carving and used to cast the concrete murals, Point chose to create another work of art from this cedar template. Revisiting this work, she added more intricately carved areas, altering the piece graphically and conceptually to create a unique image. Point's return to the sixteen cedar panels is not a surprise; the theme of the renewal of natural resources is mirrored in her reworking and refining of the original carving.

The imagery in this work honors the Coast Salish people from the area around Alki Point in West Seattle. Alki was a celebrated gathering place for Coast Salish peoples of the area, particularly during times when the fishing was good. The human face central to the image represents not only the

people who lived in the area so many years ago but also those who live there today. The face also can be interpreted as an icon of the land; fish indicate the sea; and birds the sky. The fish abundant with life-giving eggs and the baby bird nestled within the adult bird reinforce Point's theme of renewal and new beginnings.

Stewarding the recovery of historical imagery, Point offers contemporary interpretations and renewal for almost-forgotten cultural iconography. Throughout her career, Point has encountered in various books and articles photographs of a particularly haunting Coast Salish sculpture that left an imprint within her mind (fig. 12). The historical sculpture, collected at Bay Center in southwestern Washington and now in the collection of the American Museum of Natural History, is called a Coast Salish "shaman's board" in some references and simply a "house plank" in others. This carving has been a source of inspiration and empowerment for many of today's Coast Salish artists. Over time, this simple, powerful figure stuck with Point until she finally had the opportunity to see it on a trip to New York in 1996. Point patiently waited for an opportunity to honor the work with an interpretation of her own.

"I know this piece [the original] appears very simple in design," Point explains, "but it is such a strong image; and it has always been in the back of my mind. I think that, subconsciously, this is an image that anyone would remember." Point is not so much concerned with the function of the piece as with the powerful, commanding image it leaves in the memory and in the soul of anyone who encounters it.

Point's old-growth western red cedar carvings *Male House Plank* (fig. 13) and *Female House Plank* (fig. 14) are Point's contemporary versions of the older shaman's board. On the back side of each house plank, Point has carved a detail of an ancient Coast Salish weaving pattern. Although these planks share the monumentality and stateliness of Northwest Coast totem poles, they are exemplary of the differences between the Northern Northwest Coast tribes and the southern ethnological groups.

Unlike their northern neighbours, the Coast Salish did not carve totem poles. Instead, they carved designs into house posts, the structural posts used to support the large roof beams of traditional longhouses. These posts were carved with a curved notch at the top where the beams would rest. The Coast Salish carved and painted stories and histories on these posts. Unfortunately, few examples of sculpted Coast Salish house posts still exist. Many were destroyed, though a small number were collected during the historical period and made their way into the world's museums. A few appeared in paintings by Europeans documenting the interior of longhouses.

11 **Water—The Essence of Life** (overleaf), 2003, Susan Point. Western red cedar; 8 × 8 feet.

12 **Shaman's Board,** artist unknown. *Courtesy of American Museum of Natural History Library, 16.6946. Photograph by Chesek/ Beckett.*

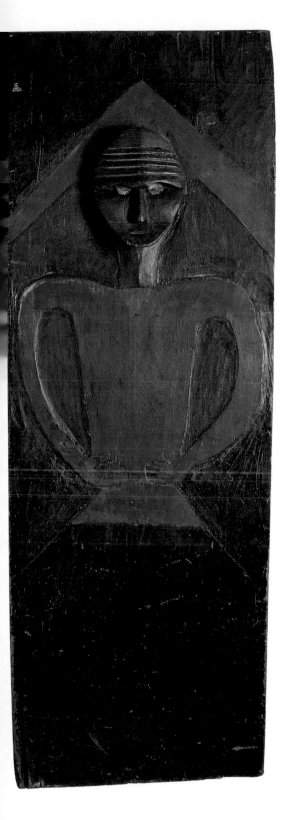

Like much of her work, Point's series of four unique glass and mixed-media house posts (figs. 15–18) is a modern interpretation of an old theme or object from her Coast Salish heritage. The Seattle House Posts series is a tribute to the southern Coast Salish people of the Seattle area—in particular Chief Seattle, the powerful chief and statesman known for his wisdom and hospitality.

Chief Seattle was a member of both the Duwamish and the Suquamish tribes, who were aboriginal peoples from Seattle and the surrounding areas, known collectively as the Lushootseed. Point's ancestors, recognized as the Hunquemi'nim, were from the area now known as Vancouver. These two Coast Salish tribes frequently gathered together for potlatches, winter spirit dancing, and trading.

Point's four house posts symbolize the collective house of the Coast Salish people— those who have visited before, and those who will care for it in the future.

In the Seattle House Post series, Point joins the Coast Salish carving style found on many of the original house posts with imagery from baskets, blankets, and rush mats for which the southern Coast Salish are so well known.

The first house post (fig. 15) features Point's interpretation of a prehistoric figure made of elk antler, found on Sucia Island. The figure depicted in the older sculpture wears a fringed skirt, bracelets, and anklets, and her hair is parted in the middle of her high, flattened forehead. The heads of infants on the southern Northwest Coast were shaped by controlled pressure in the cradle board as a way to raise their status; the heads of females were generally flattened more than those of males. The holes pierced along the sides of the figure's head represent pierced ears, and may have once held pendants (Wright, 1991). Her raised hands are portrayed in a position of giving thanks. Around the border of the composition Point has included images historically found in the carving and weaving traditions. Along the bottom is a water motif commonly found on Coast Salish regalia and carved implements.

The second house post (fig. 16) is based on much more recent history. The central figure is a man with his hands raised in welcome. The thin, straight nose and oval face are typical of historical Coast Salish sculpture. For Point, this figure symbolizes Chief Seattle. The thunderbirds below the figure represent Point's interpretation of Chief Seattle's vision quest, when he received the thunderbird's power from an important supernatural giver of wealth. Thunderbirds, according to Coast Salish belief, live high in the mountains and are some of the most powerful of all spirits. When the thunderbird flaps its wings, thunder crashes and lightning erupts from its eyes. The border imagery for this glass post is fashioned after motifs taken from

27

a S'Klallam whalebone club, and can be read as eye forms, scales, or spinal joints. The interlocking triangles found along the bottom compose a mountain-and-valley motif that is commonly found on baskets, bowls, and spoons from tribes throughout western Washington State.

The third house post (fig. 17) is Point's tribute to Chief Seattle's hospitality as he welcomed other peoples, including her own ancestors, to the Puget Sound area. The post features four different faces that represent the people who came from the four corners to visit, and the diverse collection of people from all cultures who have made Seattle their home. Point sees all people as one, woven together as part of the greater fabric of life. The border images come from a wooden mat creaser and a whale-bone bark shredder from western Washington. The checker and triangle motifs along the bottom were inspired by those found on a coiled basket.

The fourth and final house post (fig. 18) looks forward, representing the generations to come and the role they will play as stewards of the environment and the natural resources available to them. The abstract image of an adult and a child on this house post also includes sun, moon, earth, and star imagery, formed by carved crescents along the outside. A kiln-formed mirror located where the faces would be adds an interactive element to this piece. When looking at the house post, the viewer sees one's self reflected back, and in that reflection one sees the potential for the future. Point incorporated images from twined cornhusk bags of the plateau region to delineate the border; the imagery along the bottom represents trees. Trees are the backbone of Coast Salish art and culture, and this work pays homage to their spirits and to the blessing they bestow on humankind.

Echoing her theme of all as one, the images on Point's painted cowhide drum, entitled *Sacred Vision* (fig. 19), symbolize the Coast Salish artists coming together, honoring and preserving the traditions of the past for the community of the future. The open mouths on the painted faces are singing, communicating with each other, and the lines encircling the composition are a reminder of how we are all connected.

The beating of a drum is a powerful symbol in many cultural traditions. Not only does it signify an important ceremony or event, the drum beat continues, like a heartbeat, through generations, connecting people to each other, to the ancestors of the past, and to the people of the future. The drum is a storyteller. As it beats, the hearts and spirits of the people to which it speaks begin to share its rhythm. The drum tells its story in a way that is physical and spiritual at the same time. We hear the beat of the drum, we feel it in our hearts, and we sense it in the world around us.

Another work sharing this theme of a greater community of peoples is the collaborative work *Sharing a Vision* (fig. 20). Point explains, "I have

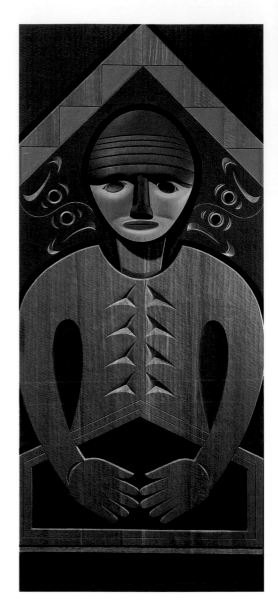

13 **Male House Plank,** 2004, Susan Point. Western red cedar and pigments; 34 × 80 inches. *Collection of Northwest Hospital, Seattle, Washington.*

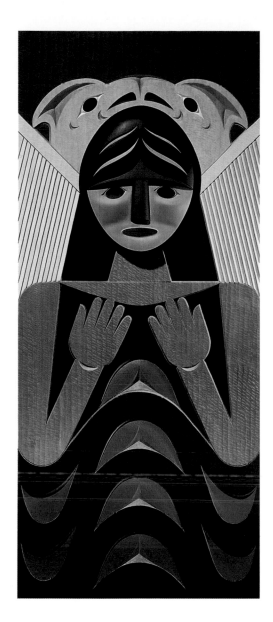

14 **Female House Plank,** 2004,
Susan Point. Western red cedar
and pigments; 34 × 80 inches.
*Collection of Northwest Hospital,
Seattle, Washington.*

sometimes observed in old pieces intertribal influences between First Nations of the Northwest Coast. One of our Salish Nation's closest neighbours are the Kwakwala-speaking peoples of northern Vancouver Island. Between our two nations, I have seen old works of art that I feel bridge our traditional styles, reflecting similarities that coexist within our unique cultures." This observation is the inspiration behind *Sharing a Vision*, a collaboration between Susan Point and Maxine Matilpi, a highly regarded Maamtagila-Tlowitsis artist whose button blankets, dance aprons, and tunics are prized for their exceptional craftsmanship and artistry. *Sharing a Vision* celebrates sisterhood on many levels—between the two artists and between their two cultures.

Button blankets like this one are a common sight at potlatches and other ceremonial gatherings for people of the Northwest Coast. Draped across the shoulders of both men and women and fastened with a large pin in the front, these rectangular compositions often feature a large crest figure or mythic ancestor in the center, such as a Killer Whale, Thunderbird, or Grizzly Bear. The Kwakwaka'wakw embellished the borders of their blankets with floral or geometric designs. These garments are called button blankets because of the use of lustrous shell or mother-of-pearl buttons that accentuate the designs. In the light of a ceremonial fire, these buttons shimmer and glisten as dancers move by with the blankets spread out, the crest figure nearly taking flight.

Matilpi's first choice for a base fabric is melton cloth, which is denser and thinner than the original Hudson's Bay Company wool blankets of her mother's generation. Matilpi is known for her appliqués made of stroud, an old wool trade cloth which is very thin but nonfraying. The beaded outline design is Matilpi's signature technique.

The center crest figures on Matilpi's button blankets are usually designed by her husband, renowned artist John Livingston. In *Sharing a Vision,* Matilpi illustrated the border designs and Point stepped into John's role and composed the figures. John Livingston, a non-Native, and his adoptive family, the Hunts, have taught Point a great deal about carving and have worked with her on many of her larger projects—another example of how this button blanket celebrates the link between these people, their families, and their cultures.

"When creating the design for the blanket," Point explains, "I decided to keep it simple, although strongly Coast Salish, and also develop a design that would have meaning for Maxine and myself. Maxine is a high-ranking member of her people, with many honours and hereditary rights passed on to her. I know one of her favorite images is the butterfly, which came from a family crest on her mother's side. My mother's favorite, and mine as well,"

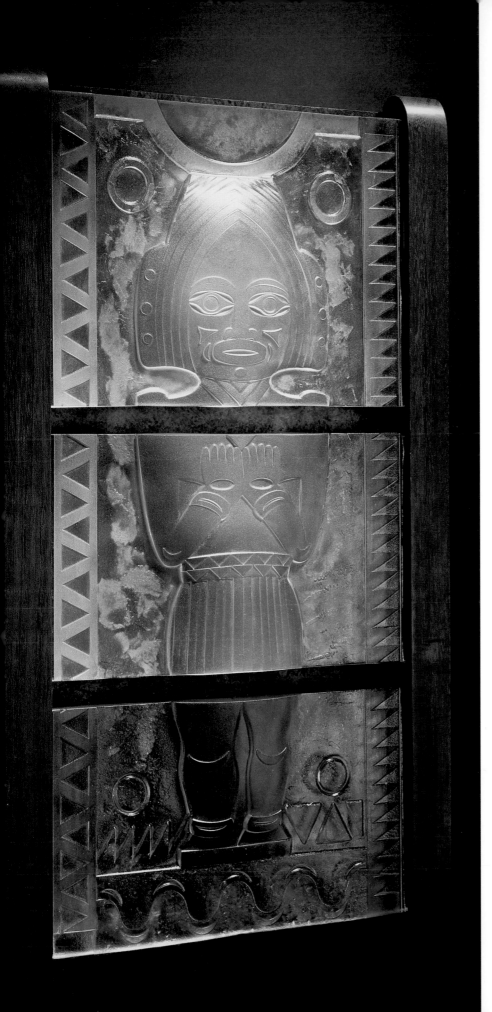

15 **Seattle House Post I, State I/IV,** 2004, Susan Point. Carved and kiln-slumped fire-polished glass, purple heart; 31 × 17 × 2 1/4 inches. *Photograph by Robert Vinnedge.*

16 Seattle House Post II, State I/IV, 2004, Susan Point. Red and sienna natural pigments fired into glass, carved and kiln-slumped glass; 29 1/2 × 23 × 3 1/2 inches. *Photograph by Robert Vinnedge.*

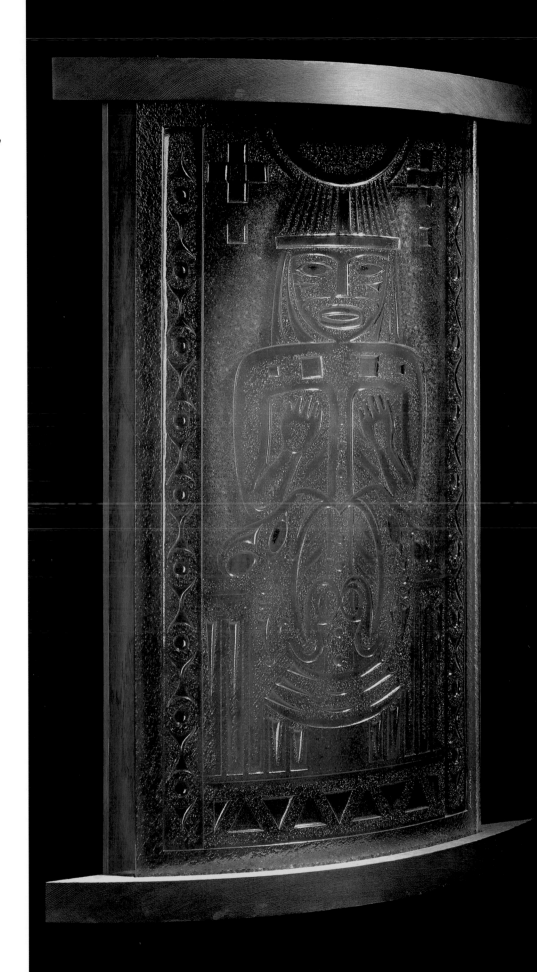

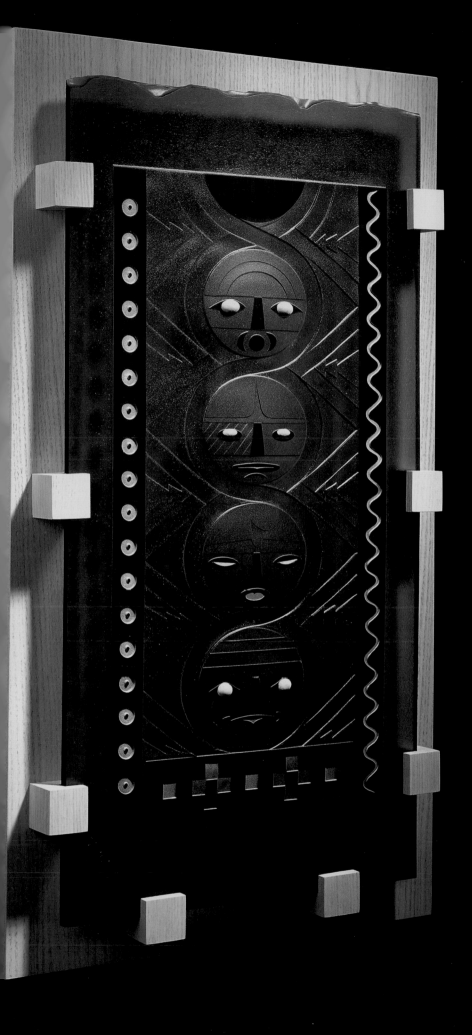

17 **Seattle House Post III, State I/IV,** 2004, Susan Point. Copper inlay, onlay patinaed onto bronze glass, carved and kiln-slumped glass; 39 × 22 × 3 inches. *Photograph by Robert Vinnedge.*

18 Seattle House Post IV, State I/IV, 2004, Susan Point. Sand-etched glass, yellow cedar, red cedar, and slumped mirror; 42 × 22 × 3 inches. *Photograph by Robert Vinnedge.*

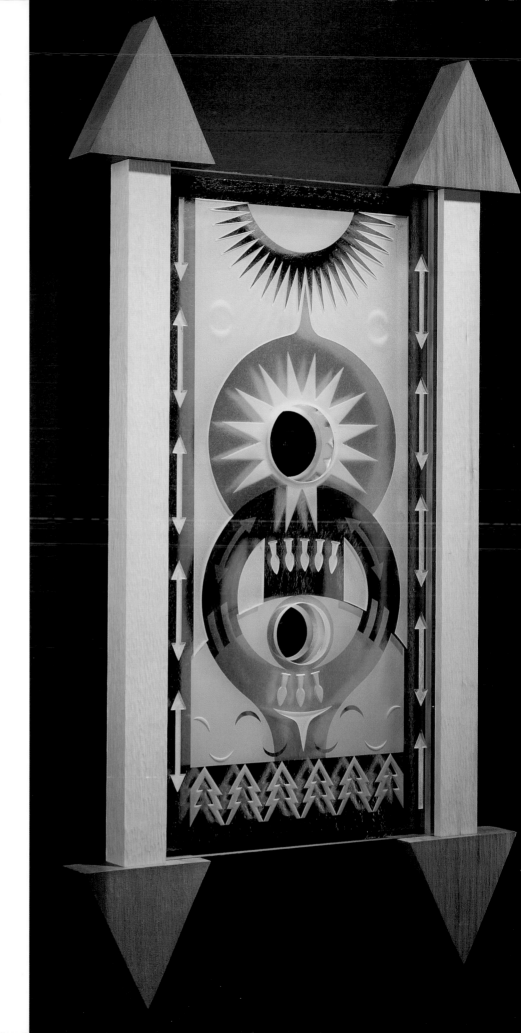

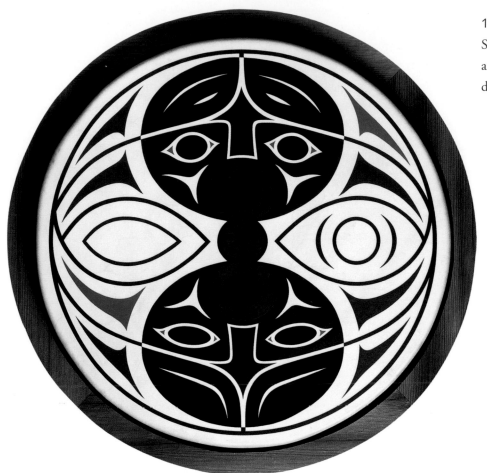

19 **Sacred Vision Drum,** 2004, Susan Point. Cowhide, acrylic, and western red cedar; 23 inches diameter × 4 inches.

Point adds, "has always been the hummingbird. The central image for this robe is taken from a historic Coast Salish wooden comb, now housed in the Peabody Museum at Harvard University. The image is that of a two-headed serpent placed within a square shape in the middle of the blanket. Around the outside at the top are two butterfly motifs for Maxine and her daughter. The four hummingbirds are for my mother, my two daughters, and myself."

Point unites another aspect of historical Coast Salish culture by wedding designs from ancient goat-horn bracelets into her contemporary Salish paddles (fig. 21). The rhythmic use of crescents, ovals, and trigons distinguishes Point's two yellow cedar paddles as Coast Salish in style. Their simple form and graphic imagery are designs drawn from early-contact period (late-eighteenth-century) goat horn bracelets. Historical Coast Salish bracelets were made of bands cut from mountain goat horn that were steamed and bent into the desired shape. Anthropologist Dr. Michael Kew described these particular bracelets as some of the most remarkable items of Salish decorative art. Point has reinterpreted the bracelet design on a much larger scale that is well-suited to the paddle form.

Point interprets a traditional utilitarian paddle form with her second set

20 **Sharing a Vision,** button blanket, 2003, Susan Point and Maxine Matilpi (Maamtagila-Tlowitsis). Wool, melton, stroud, and buttons; 52 × 85 inches.

of paddles *Chehalis Paddles* (fig. 22). The Chehalis or river-style paddle is a useful tool for moving a large canoe down a swiftly flowing river alongside fast-moving floating logs. It is easily recognized by the distinctive U-shape cut out at the end of the blade, which can be used by the paddler to push away from the canoe the logs that threaten to shatter the hull. Point's Chehalis paddles, each made of strong maple, are typical of the Chehalis river-canoe style of the Southern Coast Salish. The images that adorn the blades illustrate various stylized animal figures in motion.

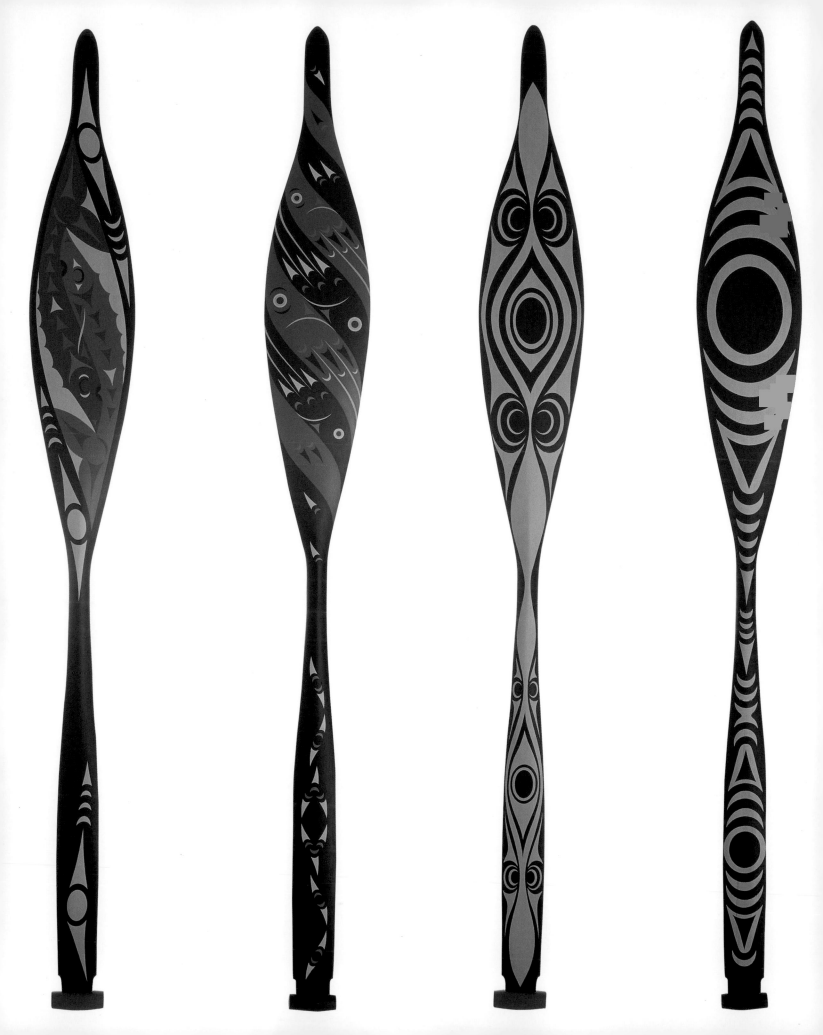

21 **Salish Paddles** (fronts), 2004,
Susan Point. Yellow cedar and
acrylic; length 5 feet.

Salish Paddles (backs)

22 **Chehalis Paddles,** 2004, Susan
Point. Maple and acrylic; length
5 feet.

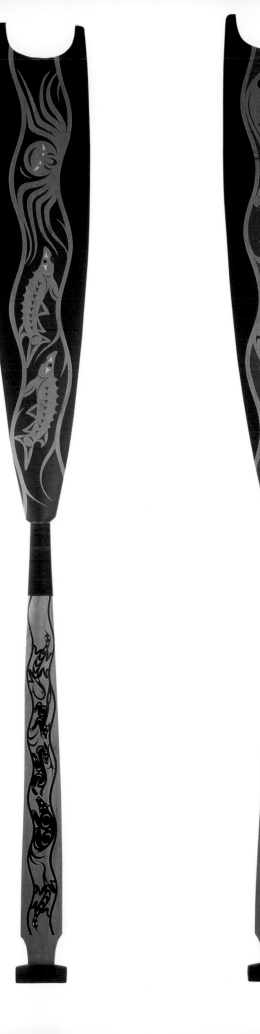

23 **Susan Point** carving *North-wind's Fishing Weir* at her studio in Vancouver, British Columbia, 2004. Western red cedar, acrylic paint, and copper onlay; 44 × 144 inches. *Photograph by Kenji Nagai.*

24 **Southwind with Mountain Beaver Woman,** 2004, Susan Point. Serigraph; image 15 × 20 inches. *Photograph by Tod Gangler.*

25 **Northwind,** 2004, Susan Point. Serigraph; image 15 × 20 inches. *Photograph by Tod Gangler.*

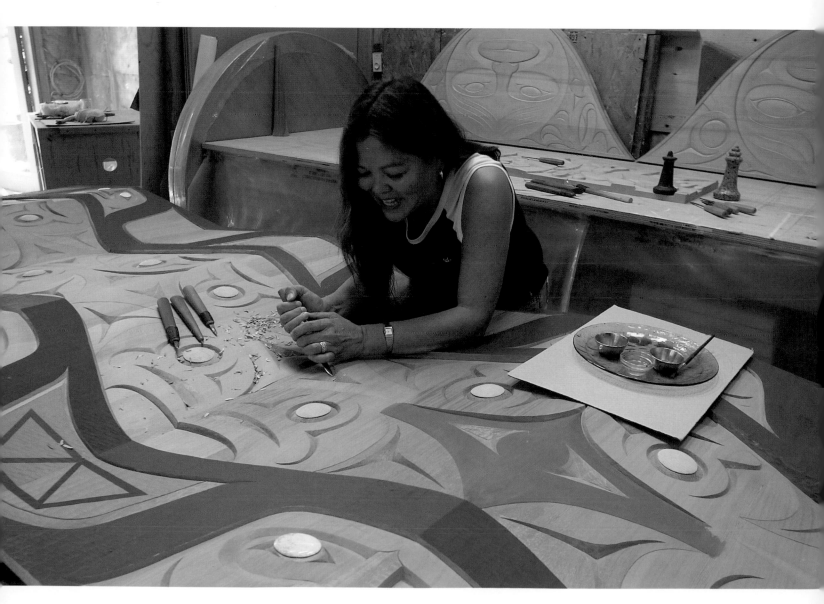

Legend of Northwind's Fishing Weir

In her mural Northwind's Fishing Weir *(fig. 23) and the following series of serigraphs (figs. 24–29), Point has chosen to illustrate the legend of Northwind's fishing weir, which offers an explanation for the cold of winter.*

NORTHWIND, A POWERFUL HEAD MAN, lived in a winter village on the west bank of the river. Upstream was the winter village of Southwind, another formidable head man, and his people. A deep hostility between Northwind and Southwind grew even stronger when both powerful chiefs sought to claim the beautiful Mountain Beaver Woman as their own. When Mountain Beaver Woman chose Southwind as her mate, Northwind and his people were enraged. They attacked Southwind's village. The only survivors were Mountain Beaver Woman, now pregnant with Southwind's child, and an old woman who was Southwind's mother, one who wrought magic and spoke to the spirits of nature. But the old woman's powers were rendered useless, locked in dirty ice that Northwind froze to her face.

Northwind led Mountain Beaver Woman back to his village in shame as his slave. She later gave birth to a son, Little Mountain Beaver. As Northwind ruled, he used his power to make the land unbearably cold. Lakes and streams froze. In greed he built a fish weir of ice across the river so that no fish could swim upstream to spawn. The people upstream were starving. Their misery drove many to try and go below the ice barrier to fish. But when Northwind caught them he forced them to weave a rope of hazel saplings, and then used the same rope to hang them.

As the people endured Northwind's cruelty, Little Mountain Beaver grew into a strong and powerful man and took the name of Stormwind. Northwind allowed him to travel wherever he wanted, but warned him to stay away from a certain hill upstream. For years, Little Mountain Beaver obeyed. Then, one day, he found himself climbing that very hill, and saw a dilapidated mat house at the top. Against Northwind's orders, he climbed the hill and looked inside the house, where he found a filthy old woman weaving baskets and singing an anguished lament. She was all alone except for two loyal servants—a rat and a mole. Baskets were stacked high all around her. Some were large and open, others were medium-sized, and some were very small, woven so tightly that they were nearly watertight. The old woman took the curious young Stormwind by surprise. She told him that she was his grandmother, and that Northwind had brutally murdered his real father and his people. Reunited, the two kin plotted their revenge.

The young Stormwind told no one of his discovery. He began to display a new-found strength that frightened the people of Northwind's village. Stormwind would secretly tear down large, ancient trees and throw them into the river, where they would float downstream and lodge against Northwind's ice fish weir. Although many tried, no one in Northwind's winter village, including Northwind himself, was strong enough to dislodge the logs. As they struggled and strained against the great logs, Stormwind would casually stroll along the bank and effortlessly flip the massive trunks over the weir, much to the shock of the villagers.

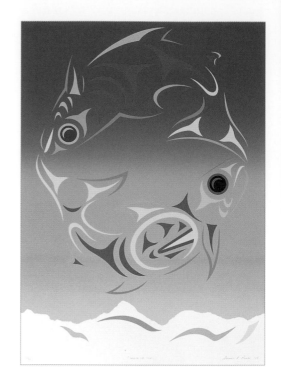

Northwind took note of Stormwind's strength, and began to fear for his position as head man of the village. In an effort to form a bond with Stormwind, Northwind dressed his eldest daughter in lavish necklaces and bracelets of ice as a dowry, and sent her to Stormwind as a marriage offering. But before Northwind's daughter could even enter Stormwind's doorway, his warm breath melted her ice jewelry, leaving her without a dowry. Over and over this happened. Northwind began to suspect that his worst fears had been realized—Stormwind had discovered his true identity, and was resolved to avenge the death of his father and his villagers. Northwind had no choice. He decided he must kill Stormwind before the younger man became invincible. But Stormwind and his mother escaped Northwind's attempt, and made their way to the grandmother's shack.

After so many years, Stormwind's grandmother was ready for battle. Stormwind melted the filthy ice from her face and restored her powers. Then, Stormwind began to blow. Tree after tree fell into the river as Stormwind continued to blow. The trees filled the river and jammed against the fish weir. Northwind's people grew terrified and refused to leave their longhouses. Stormwind's grandmother filled her many baskets with water and emptied them over the land. The rains poured over Northwind's village and raised the river until the pressure against Northwind's ice weir grew to be too much, and the weir collapsed. Its remains turned to stones, which can still be seen when the water is low. The flood swept Northwind's village away and Stormwind chased Northwind down the river valley, across what we now call Puget Sound, and on to Bainbridge Island. To this day the final battle of Northwind and Stormwind is replayed in the breakers that roll so ferociously off Yeomalt Point.

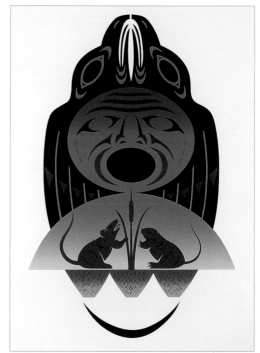

Although Stormwind triumphed and avenged the death of his father and his villagers, Northwind was not entirely defeated. He was permitted to return to the valley to visit Mountain Beaver Woman for a few months every year. This, they say, is why it is cold during the winter season.

26 **Weir of Ice,** 2004, Susan Point.
Serigraph; image 15 × 20 inches.
Photograph by Tod Gangler.

27 **The Old Woman,** 2004, Susan
Point. Serigraph; image 15 × 20
inches. *Photograph by Tod Gangler.*

28 **Storm Wind,** 2004, Susan
Point. Serigraph; image 15 × 20
inches. *Photograph by Tod Gangler.*

29 **Northwind Returns,** 2004,
Susan Point. Serigraph; image 15 × 20
inches. *Photograph by Tod Gangler.*

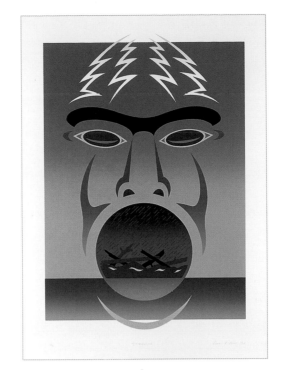

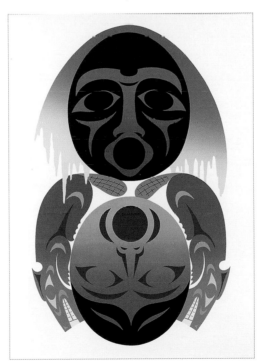

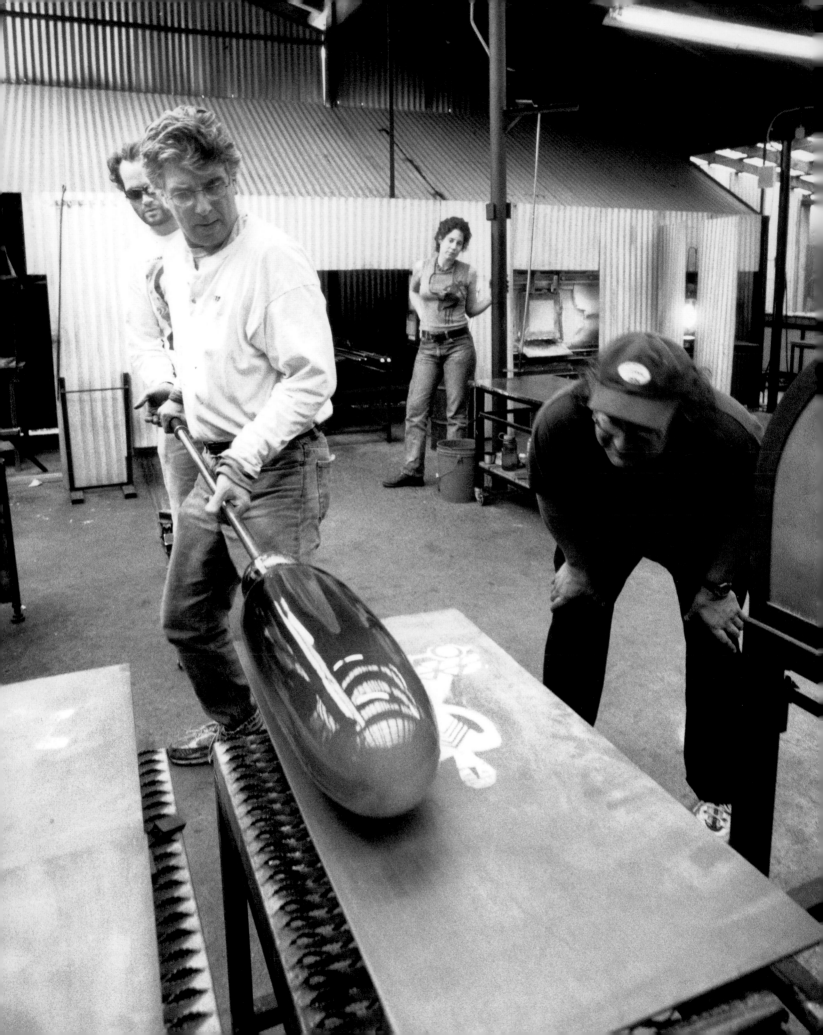

Marvin Oliver

Marvin Oliver, of Quinault and Isleta Pueblo descent, is distinguished for his role as artist, teacher, and innovator. Challenged by combining ancient Northwest Coast forms with modern nonorganic materials, he has created a body of work representing a remarkable synthesis of intellect, creativity, and energy, uniting the past with the present. Oliver states, "My works are formulated by merging the spirit of past traditions with those of the present to create new horizons for the future." His passion for technology and his innovative nature compelled Oliver to use computers as his primary design tool, making him one of the first Northwest Coast artists to pioneer this approach.

Simultaneously, Oliver sparked the contemporary glass movement in Northwest Coast art through his search for a new material to express his Native heritage. Oliver's exploration of glass as a medium has spanned more than a decade. Currently, he coproduces artworks with a group of expert glass artists. Oliver values the dimension and transparency glass affords, allowing him to suspend his images, rather than taking the more traditional approach of carving or painting them onto cedar.

As an associate professor in the American Indian Studies department at the University of Washington and as curator of contemporary Native art at the University of Washington's Burke Memorial Museum, Oliver has given people a foundation for a better understanding of the history of Northwest Coast cultures.

The ground-breaking *Transporter* series was created by Oliver and the glassblowing team at the Benjamin Moore Glass Studio in Seattle, Washington. Each handblown sculpture represents Oliver's contemporary vision of the traditional spirit canoe boards used by Coast Salish shamans. Spirit canoe boards were wooden panels that were part of an elaborate shamanic voyage to the land of the dead to recover lost souls (Wright, 1991: 37–39). To make the journey, the boards were arranged in the form of a canoe in which the shaman paddled his way to the land of lost souls of the sick (Gunther, 1962). The images painted on the boards represent the spirit powers that helped the shaman. In Oliver's *Transporter* sculptures the ravens are the messengers of the transporter. They can talk to anyone, including the spirits. They appear in different colors; their feathers, illuminated by the sun, change in color and aura. "I like using ravens," Oliver says, "because of their awe-inspiring mythical connection to past, present, and future. And I like using the circle because it is continuous, with no beginning or end and no corners to confuse us."

Oliver describes one of the transporters (fig. 31): "The large faces that

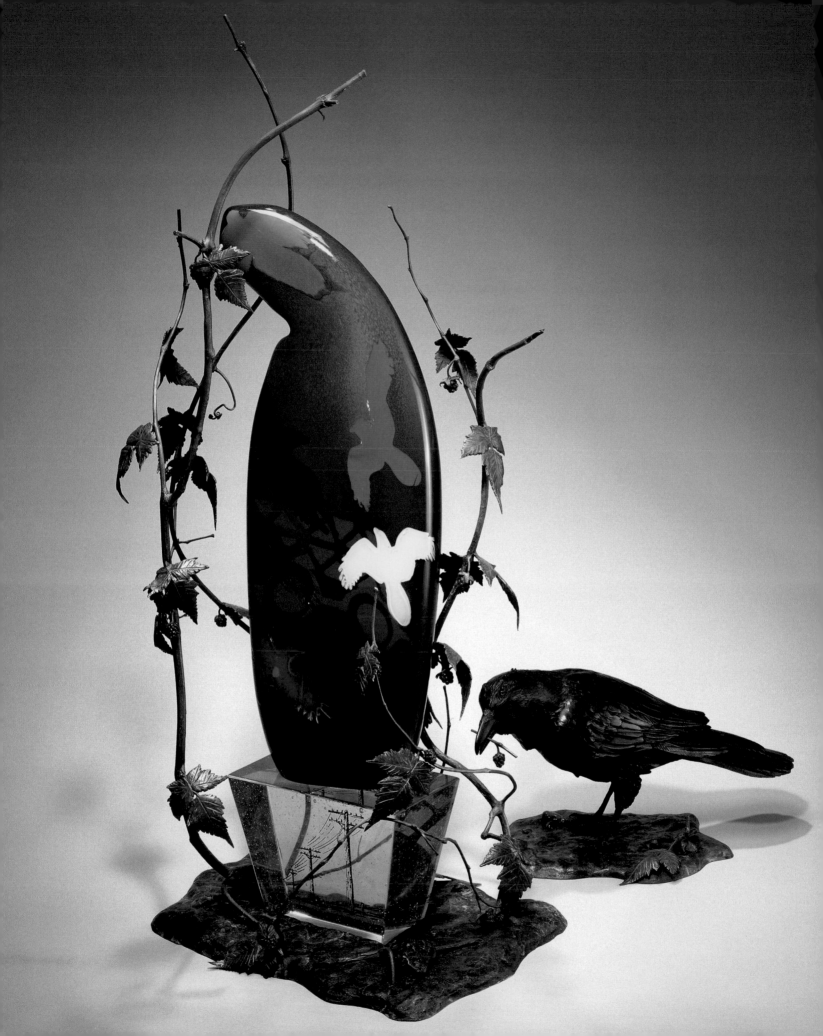

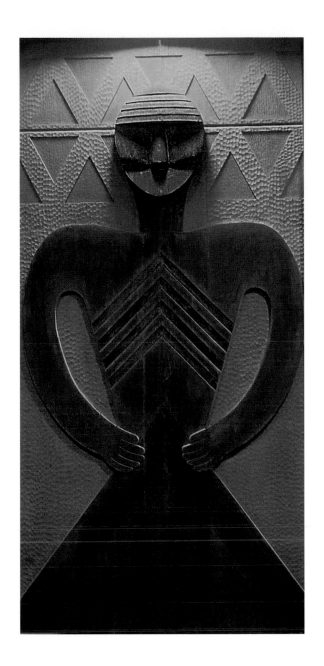

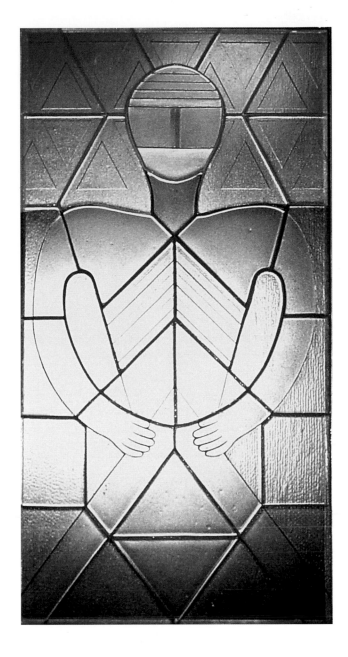

31 **Transporter I** (*opposite*), 2004,
Marvin Oliver. Handblown glass,
cast glass, and bronze; 46 ×
24 × 18 inches. *Photograph by Robert
Vinnedge. Bronze cast: Tyler Fouts
Blue Mountain Fine Art, Walla
Walla, Washingon.*

32 **Transition I,** 1988, Marvin
Oliver. Carved cedar panel; 72 ×
34 1/4 × 2 1/25 inches. *City of Seattle,
Portable Works Collection. Photograph
by Marvin Oliver.*

33 **Transition II,** 1988, Marvin
Oliver. Cast glass panel; 72 3/4 ×
37 1/2 × 2 inches. *City of Seattle,
Portable Works Collection. Photograph
by Marvin Oliver.*

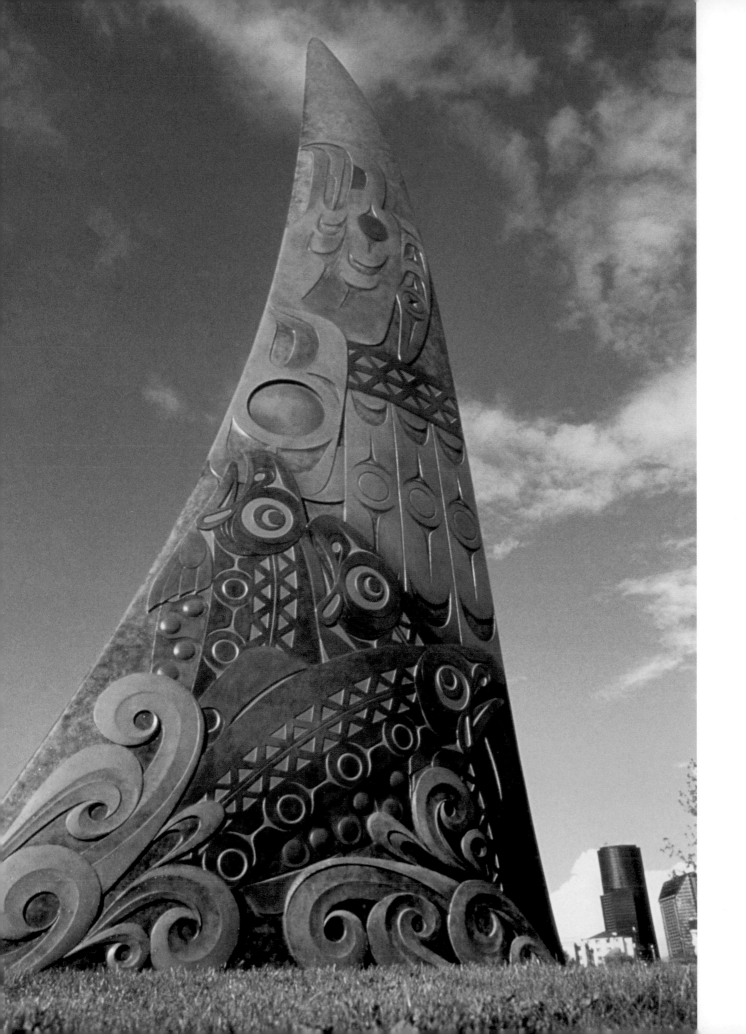

34 **Spirit of Our Youth,** 1996,
Marvin Oliver. Cast bronze and
earthworks; 312 × 96 × 24 inches.
King County Arts Commission,
Seattle, Washington. Photograph
by Marvin Oliver.

appear in the background are ghosts. The ghosts peer through time, ever watching—protectors of past, present, and future. The 'dark side' of the *Transporter* represents the unknown—not bad, just unknown. This is where Raven lives. He can see through darkness. The 'light side' is our field of reality, which beckons for universal truths, such as honesty and respect for us and others, either living or dead."

Oliver continues, "The base of the *Transporter* represents the 'at present' or 'now' and how we communicate today. The telephone wires depict our current communication [i.e., physical technology such as telephones and computers]. We also communicate through our own spirit and intuition to achieve our personal goals, similar to the shamans of yesterday and today. The base also represents the shovel [or spade] that traditionally was put into the ground to hold the board upright. The vines and berries growing up and around the vessel symbolize life connecting us to the past." The Coast Salish power figure appears frozen in time, a messenger from the ancient Quinault people, awakening the muted voices of his ancestors to speak again.

The two *Transition* sculptures created in 1988 for the City of Seattle 1% for Art Portable Works Collection preceded the Transporter series and were the foundation for Oliver's exploration of Coast Salish power objects. Oliver explains his process in creating his carved cedar panel *Transition I* (fig. 32): "Traditionally, Quinault power figures are carved in wood. I chose to create a transition between solid wood and transparent glass, a reflection of my curiosity and my intuitive instincts for innovation through art."

When referring to his cast glass panel *Transition II* (fig. 33), Oliver says: "In my Native Quinault culture, we acquired many different powers to guide us through our life journey. We all have engaging powers that assist us on our own personal ventures in life. I have chosen art as one of my selective powers.

"*Transition I* and *Transition II* resemble my power of creativity, especially through glass. I am a sculptor who uses glass as a means of transcending light to create a transparent, multi-dimensional work of art. I often wondered what my power figure would look like in art glass. This is what inspired me to create them."

Spirit of Our Youth (fig. 34) was commissioned by the King County Arts Commission for Remington Court Park in Seattle, Washington. The twenty-six-foot fin and the imagery on its sides offer hope and guidance for youth by celebrating the strength found in family and community. The whale and its pod implied by the fin represent the importance of family bonding. The relief of the leaping salmon pregnant with eggs on the fin represents the endurance of life, as well as its cyclical nature. The thunderbird soaring above is a symbol of power, strength, and survival. The earth

surrounding *Spirit of Our Youth* is landscaped to suggest the rolling waves of Puget Sound as the orca breaches the surface.

The sculpture was cast at the Walla Walla Foundry in Walla Walla, Washington. There are sixteen sections to a side. The sculpture weighs nearly two tons. The thirty-two bronze panels were welded to a steel armature to contain its massive weight.

Journey (fig. 35) originated as the model for *Spirit of Our Youth*. *Journey* features a thunderbird in shallow relief on the killer whale's dorsal fin. To Oliver, "the thunderbird represents strength and survival, and the use of the orca dorsal fin as the canvas denotes good luck."

The orcas' journey involves traveling long distances as they follow the North Pacific salmon runs, their primary food source. One can sometimes see the dorsal fins gliding through the waters of Puget Sound as they travel in pods looking for food. The hunt heats up in summer as the salmon return from the Pacific on their way back to their rivers of origin to spawn and die. Before recent times, this annual salmon migration also provided a critical food source for the Coast Salish, who depended on these runs to sustain them through the winter months.

Like much of Oliver's art, this sculpture suggests that existence and survival draw upon our spiritual, physical, and communal strengths, and, in turn, define our journey.

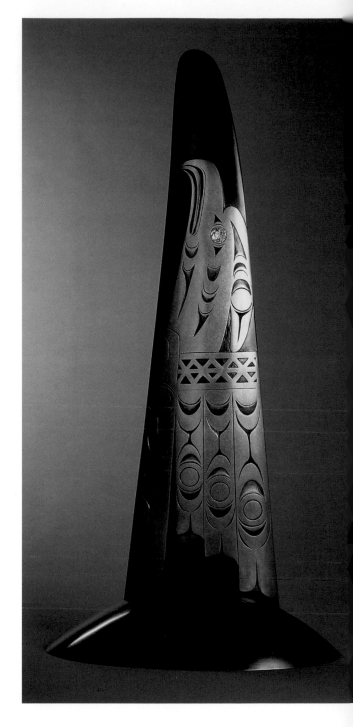

35 Journey, 2003, Marvin Oliver. Bronze with abalone inlay; 35 × 16 × 10 inches.

Shaun Peterson
PUYALLUP/TULALIP

Maynard Johnny, Jr.
COWICHAN

Luke Marston
CHEMAINUS

John Marston
CHEMAINUS

Rekindling Spirit

THE COLLECTIVE MOMENTUM OF TODAY'S Coast Salish resurgence sparked a spirit of passion and dedication in the younger generation of artists. The desire to cultivate this spirit has profoundly impacted the lives of these four. As with their elders before them, there is essentially no division between their lives and their art. The role of these young artists is complex. Taking on this responsibility requires them to uphold and preserve their heritage through their art. The creation of ceremonial objects demands an understanding of the history of ritual within their lineage. Realizing that so much cultural information is held in the memories of their parents and grandparents, they feel an urgency to learn as much as they can, as soon as they can. Their education is two-fold. It combines learning their accumulated tribal histories along with their studies of Coast Salish design principles. This comprehensive approach to understanding their heritage enables them to rekindle the spirit of their culture and keep the vision alive for future generations.

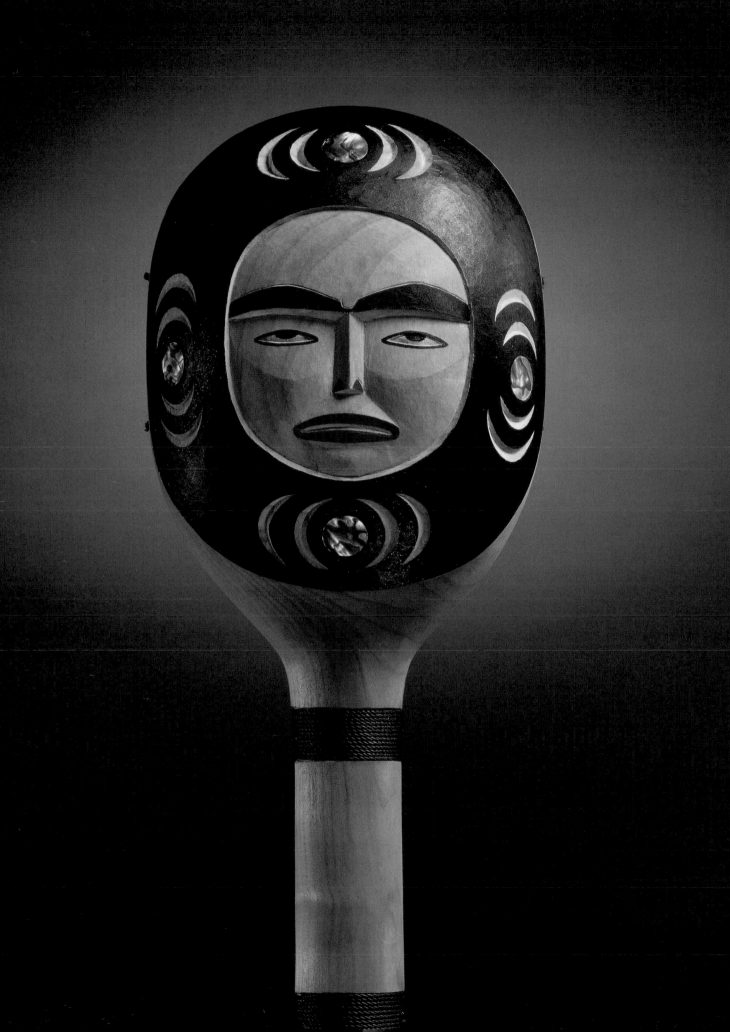

Moon and Frog Rattle, 2003, Shaun Peterson. Yellow cedar, abalone, and pigments; 10 × 3 3/45 × 3 1/2 inches.

Shaun Peterson

Shaun Peterson was born in Puyallup, Washington, in 1975 and is a member of the Puyallup tribe. Peterson's work is based in the ancient tradition of the Salish-speaking tribal groups that cover a majority of western Washington and parts of southern British Columbia.

Upon his introduction to the Northwest Coast Native art discipline, Peterson worked with a select group of artists skilled in their field of expertise, including Haida artist Bruce Cook III, Steve Brown, Greg Colfax (Makah), and Loren White. Working with these individuals, Peterson learned a great deal about the variety of styles that compose the visual lexicon of the cultural groups of the region. In his quest to understand the defining artistic features of his own cultural group, he found that there was minimal documentation readily available on Salish art. Peterson then began rigorously studying museum collections to learn about the art that was in many ways forgotten among his own people. At first drawing from historic pieces for inspiration, Peterson eventually learned to utilize the properties that defined the Coast Salish style and to generate new creations based upon his collective experiences and explorations. His early work was primarily functional and related directly to ceremony in the form of painted drums, rattles, and masks.

Peterson has begun to integrate more nontraditional media into his art, such as glass and metal, while maintaining the defining features that make the art culturally identifiable. Peterson has created public works for the cities of Tacoma and Seattle, as well as site-specific work for tribal buildings in his community. Peterson's work, in the form of limited edition prints, masks, rattles, hand-carved cedar panels, etched glass, and metalwork, is both traditional and contemporary, drawing on the artistic disciplines of the past and using modern materials.

Legend of the Origin of the Moon

Peterson's subtle but powerful alder carving Moon and Frog Rattle *(fig. 36)*
depicts the legend of the origin of the moon. This legend is the Puyallup
version of the southern Puget Sound story of the creation of the moon
and the unexpected union of Changer (Moon) and Frog Woman.

MOON WAS CONCEIVED WHEN HIS human mother and her sister climbed a gigantic cedar tree to reach the Sky World, where they met and married their true loves—White Star and Red Star. The younger sister was already carrying her unborn child when the two sisters decided to return to the human world.

When this child was born he displayed great supernatural gifts. He came to be known as Dakwibalth, meaning "Changer" or "Transformer." All that posed a threat to humans was weakened by Dakwibalth's powers. Although humans were considered a joke in the supernatural world, being half human made Dakwibalth sympathetic towards humans and their struggle to understand their world. Wolf was one of the few creatures to take pity on the humans as well. Together they taught man to fish and hunt, to organize and work together.

As Changer became an adult he decided to return to the Sky World to fulfill his destiny as the Moon. Word spread quickly that Changer wanted to marry. Women made themselves more beautiful to attract him, but he declared that he would only marry a woman who was strong enough to lift the Great Cedar Basket that held the stories and teachings of the ancestors. Many beautiful women tried to lift the basket and failed. They all laughed when Frog Woman stepped up to try, but to their amazement she lifted the basket high above her head and became Changer's wife. Before he left for the Sky World to become Moon, Changer asked Wolf to watch over his people. Now, when the moon is full, Wolf sings to tell him what he has missed in the passing days.

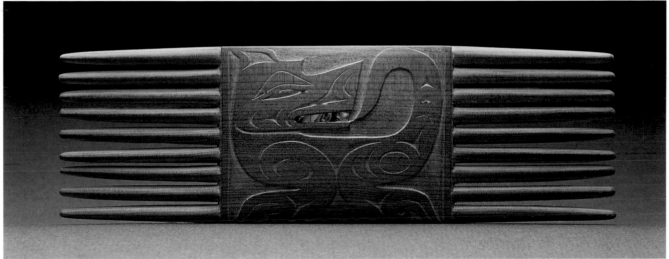

37 Wolf and Moon Comb, 2004,
Shaun Peterson. Yew wood; 7 ×
3 3/4 inches.

Shaun Peterson explains the importance of the Wolf image in the
Puyallup tradition: "Wolf has been described to me through the teachings
of our people as a source from which we can learn a great deal of respect.
From Wolf we have learned to work together and have respect for those of
rank and nobility. Wolf has also been a keeper of justice within the old sto-
ries that continue today. The wolf is revered for these characteristics in other
parts of the world as well. I hope to pay respect to not just an 'animal' but
an ancestral leader through the art that I create."

This respect shows through in his detailed and subtle approach to carving
the wolf and the moon in yew wood in his *Wolf and Moon Comb* (fig. 37).
The Coast Salish used combs for various purposes. One unique use for
combs was to aid in separating the stalk filaments of the nettle plant for pro-
cessing into the weft strands of blankets (Gustafson, 1980). The combs were
also employed to prepare mountain goat and dog fur for weaving.

Legend of Wolf and Moon

Respect, tolerance, and trustworthiness can all be learned from the southern Salish "Legend of Wolf and Moon," a story about one's capacity to love. The simple loyalty between Wolf and Moon, as told in the legend, can be felt in Shaun Peterson's delicate yew wood carving of a Salish comb.

LONG AGO MAN WAS RATHER LOST IN THE world between both the natural and supernatural. The spirits that had become tangible early on had found their roles and places. Much to the animal world's amusement, man was clumsy about providing for himself. The animals did not all find this humorous, though. Wolf was one of the few who was sympathetic towards man in his unfortunate situation. Wolf decided, out of kindness, to help in teaching humans what he could. Wolf had taken the bark from the cedar tree and made a neck ring that kept him warm. He taught man to make clothing which could shield his body from the rains. He also taught man to make a net and canoe from the cedar tree so that he could fish and nourish his body. Man worked hard at accumulating these skills, and Changer (Dakwibalth) was working hard as well. Changer was known to have taken many powers away from the animals who were harming man. Snake was one who suffered here, for he once had venom [snakes in the Pacific Northwest are generally not poisonous]. After all these things had taken place, Changer decided he would return to the Sky World and become Moon. Yet before Changer would leave, he wanted to be assured that the people would be looked after. Wolf was approached by Changer to be the guardian of humans, given that he was the first to offer them help. Wolf agreed to watch over the people, and so it is, when the moon is full, Wolf sings to him to let him know that he is fulfilling his promise.

Legend of How Wolf Daughter Became Human

Following is the love story of how Wolf Daughter became human, as told by Shaun Peterson.

LONG AGO THERE WAS A CHIEF OF THE S.Puyallapubsh [Puyallup] people. This chief had a handsome son who displayed great promise as a future leader. The young man had been preoccupied with his future responsibiities and thus neglected the notion of a romance, despite his appeal to the many young women in his village.

As the young man approached his coming of adulthood, his father felt it necessary to test his skills and wit. This test was important to help him learn the responsibility of how to protect himself in the future.

One day an elder saw a large wolf prowling along the banks of the river where children would often play. The chief immediately asked his son to find and kill the wolf.

The chief's son was aware that this request was to test his leadership and skill. He threw his bow and arrows into his cedar canoe and set off up the river. Having left in a hurry, he hadn't packed any food for the venture he was embarking upon.

After searching the riverbanks without any sign of the wolf, the chief's son began to get tired. The young man dragged the canoe from the river and placed it under a large tree which grew out over the river. On this particular night the young man was exhausted and retired to his canoe to cover up with his blanket. Soon after he fell asleep, a mother wolf and her young daughter passed under the tree where the young man was sleeping. The wolves smelled the man and decided to investigate. Encouraged by her mother, young Wolf Daughter went on to see what was in the canoe.

"He looks very healthy," said Wolf Daughter to her mother. She then pulled down the blanket that concealed the young man's head. When she brought her mouth close to his, she felt his warm breath and realized he was alive. By the bright light of the moon, she could see how handsome he was, and she fell in love.

"Let's eat him," suggested Mother Wolf. "No, he's too fresh," said Wolf Daughter. She had decided to save his life. "We should take him home so that the other wolves can't share our dinner." "I'm so hungry," replied Mother Wolf. "Why don't we eat him now?" "We don't have time," answered Wolf Daughter. "The stars are almost gone. If we stay here much longer we will be in too much danger."

The mother and daughter quickly lifted the young man out of the canoe.

By using the man's blanket as a sling, the wolves took him to their den and laid him on the daughter's bed of soft grasses. Mother Wolf was tired and soon fell asleep. When Wolf Daughter was sure her mother was asleep, she hurried outside of the den and gathered some plants with magical properties that were growing nearby. She placed the plants under the noses of the young man and her mother, causing them to sleep even more soundly.

Wolf Daughter ran toward the giant mountain, which was covered with ice even in the summer. At a secret place near the base of the mountain, she hoped to find Big Elk, her spirit guardian. She found Big Elk just as he was about to leave the hiding place where he had spent the night.

"What could you want so early in the morning?" asked Big Elk. "I want you to do me a great favor," answered Wolf Daughter. Big Elk had an idea what Wolf Daughter wanted even before she asked. Big Elk had young daughters of his own, and from the shy manner in which Wolf Daughter spoke, he suspected she was in love.

Wolf Daughter told Big Elk all about the young man and proclaimed that she was in love with him. She knew that she could not marry him as long as she was a wolf. She begged Big Elk to change her into a human girl so she could become his wife.

"I'll grant your wish," said Big Elk. "But first you will need a maiden's clothing. The blind witch lives in a longhouse where the saltwater narrows and runs swiftly like a river. During many years of evil deeds, she has taken clothing from many maidens, including a beautiful dress that she took from the daughter of a chief. As soon as you are inside the old woman's house, find the dress which belonged to the chief's daughter and go to the river. Hang the dress on a branch so that it is reflected in the water. You must then dive into the water. When you return to the surface, you'll be transformed. The clothes will fit you perfectly. But remember, all of this will happen only if you promise to be a loving wife."

Wolf Daughter thanked Big Elk and ran as fast as she could to the house. Fortunately, the old witch was not at home. Wolf Daughter went into the house and found a great pile of beautiful clothing. On top of the pile was a dress that was more beautiful than any clothing she had ever seen. Wolf Daughter quickly took the dress and hung it where Big Elk had told her, then she dove into the reflection of the dress in the cool water. The water was deep and icy cold. When Wolf Daughter reached the bottom of the river, she shed her wolf skin. Climbing out of the water, she stood up and found that she was standing on two feet rather than four.

The water soon became quiet. When Wolf Daughter looked into the reflection on the surface she saw a beautiful young woman. Pleased with her transformation, she put on the lovely dress. Thinking only of the young

man and hoping she would be worthy of him, she ran back to the den where she had left him sound asleep.

When the chief's son finally awakened in the dark wolves' den, he was frightened. He immediately ran to the mouth of the den, where he saw many bones strewn over the ground. The young man knew he was in danger and returned to where he'd been sleeping to see if he could find his war club. As he was searching for the club, the young brave saw the loveliest maiden he had ever seen walk into the den. She was dressed in the clothing of a princess. Her long black hair was damp and hung around her shoulders in heavy strands.

The girl slowly approached the young man and said, "Don't be afraid, this wolves' den is my home. Come with me and I will guide you home."

A little confused, the chief's son went with the girl. On the way, Wolf Daughter explained how she came to be human and that the wolves were her people. After their return to his village, the chief's son explained to the people that from then on they would have respect for the wolf people and not bring them harm. In a short time afterwards, the two were married and they lived in peace.

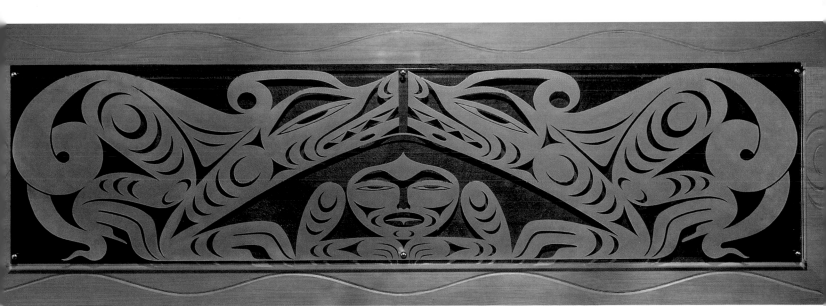

38 Wolf Daughter Becomes Human, 2001, Shaun Peterson. Red cedar, sand-etched glass, graphite, and stainless steel; 96 × 36 × 3 inches.

Wolf Daughter Becomes Human (fig. 38) is a piece that Peterson conceived in honor of the richness of Coast Salish stories. The central figure of the sand-etched glass panel is Wolf Daughter. The two wolves flanking her represent her wolf skin, symmetrically shedding to reveal her human form beneath. The wave pattern on the cedar panel represents the rippling water of the river that she is diving into.

Legend of How the Birds Rescued Their Songs

In Rescuing the Songs from the Sky World *(fig. 39), Blue Jay and Eagle are portrayed in their quest to recover the bird songs trapped in the Sky World. Here is the legend as described by the oral literature of the Puyallup and told by Shaun Peterson.*

N ANCIENT TIMES THE PEOPLE DECIDED THAT the Sky World was too close to the ground and it must be raised. After much effort, the people were successful in their intention of raising the Sky World. But they did not realize that, through their actions, the bird songs had become trapped in the heavens. Distraught, the birds came together and agreed that someone must go and retrieve their songs.

The first bird to try his luck was Crow. Upon his failure, Hawk came forth and said that surely he would be able to reach the songs. When Hawk could not reach them, Eagle decided to try. With hope in their eyes, the birds looked at one another, knowing that surely Eagle would succeed. Eagle flew up high, quickly surpassing Crow's and Hawk's distance. But still the songs were out of reach, and even though Eagle could see them, he couldn't quite reach them. After much clamoring and disarray, Blue Jay called out, "My brothers and sisters, I believe that it is my responsibility to rescue the songs of our people." At this, the larger birds broke into laughter. "I'm sorry, my brother," said Eagle, "but if I cannot reach the Sky World, then I doubt that you can." Blue Jay became angered and proposed that they compete with each other to reach the songs. Eagle agreed. They both left the ground at once, but it wasn't long before Blue Jay jumped on Eagle's back. When they reached Eagle's limit, Blue Jay shot off of Eagle's back and seized the songs tightly. Returning with the songs, Blue Jay declared that from that day forth, the beautiful songs would go to the smaller of the birds and that the doubt of the larger birds would be remembered by their callous squawks and calls.

39 Rescuing the Songs from the Sky World, 2003, Shaun Peterson. Acrylic on canvas; 36 × 48 inches.

Peterson addresses another legend that explains the ways of the natural world in his cedar and glass sculpture *Spirit of the North Wind* (fig. 40). Peterson explains, "In the stories told by the old ones, things we consider today to be intangible or lifeless take form in human likeness. At the beginning, the earth was said to be inhabited by many spirits. These spirits came forth and took shape to become what they are today: deer, salmon, cedar, and so on. This is also true when the elders speak of the many winds. In particular there is the North Wind. It is he who brings the cool transition that we know in the fall and winter. It wasn't long ago that Elder Vi Hilbert said how important the coming of November was to her. It is in November that we begin our ceremonies of winter. It is the time of much work and it is the time that there is much to witness. The importance of these transac-

59

tions is nearly immeasurable. We as Native people continue to revere our traditions and the values that have been upheld by those before us. As with many Native groups of the Northwest Coast, song and dance is of enormous importance in our ceremonies. The difference between our winter songs and dances and the others is that they are very private. There are few outside of the Native community who have witnessed these things. For those who have not, I can only describe the songs as though they were the collective beauty and power of the North Wind. With this piece I wanted to convey the spirit of North Wind as if he were calling out his winter song to the people."

40 **Spirit of the North Wind,** 2003, Shaun Peterson. Western red cedar, sand-etched glass, and acrylic; 46 × 34 × 3 inches.

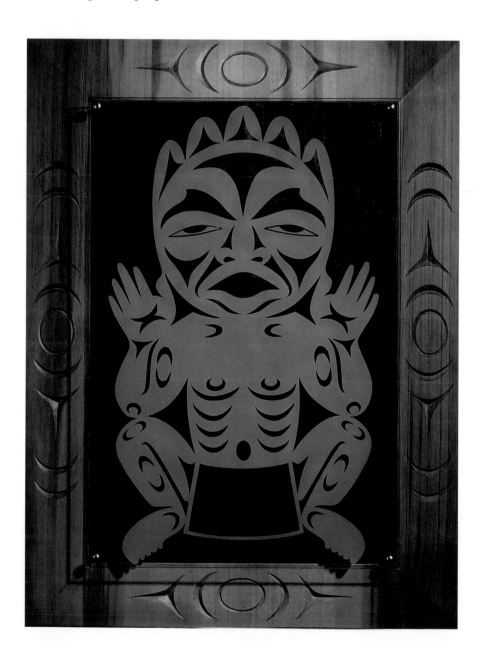

Maynard Johnny, Jr.

Penelakut artist Maynard Johnny, Jr., was born April 4, 1973, in Campbell River, British Columbia. He is of Coast Salish and Kwakwaka'wakw descent and has been creating art since the age of seventeen. His paintings and serigraphs exemplify the gracefulness of the Coast Salish two-dimensional design system. Using elegant lines and bold colors, Johnny has brought these ancient forms into the contemporary realm. His work has been strongly influenced by Susan Point, Robert Davidson, Mark Henderson, and Art Thompson.

In *Toadem Pole* (fig. 41), Johnny reveals his more whimsical, playful side with the title's pun on the northern-style totem pole. Frogs play a central role in Northwest Coast mythology, and are often associated with the spiritual power of shamans. Johnny explains, "The frog is known as the communicator between man and the spirit world. The frog is also good at catching spirits with its long tongue, and is respected for its stability."

The natural world on Vancouver Island, British Columbia, home to the Cowichan people, has become an important source of inspiration for Johnny's painting. The great blue heron that frequently perches on a fence post outside his window became the model for his painting *Blue Heron* (fig. 42). The great blue heron is one of the most frequently seen larger-sized birds of the Northwest Coast region, but one that is nevertheless a stealthy and mysterious stalker of its aquatic prey. Most often visible at dawn and dusk, these birds have startled many with their raucous, primeval squawks. The still and patient pose they assume while watching for their prey is represented here.

With his *Thunderbird Paddle* (fig. 43), Johnny successfully transitions from rendering Salish images on paper to working with the restricted space of a carved wooden paddle. The juxtaposition of curving, fluid forms contrasting with straight, rectilinear shapes comes directly from ancient Coast Salish design traditions.

The canoe paddle has become an icon to contemporary Northwest Coast Native artists because it symbolizes their ancestors' lives, which were defined and shaped by their connection to and dependence upon the water. The great canoes of the Pacific Northwest Coast are legendary for their seaworthiness, their elegant designs, and the two-dimensional formline art on their gunnels. The renewed pride of the Northwest Coast Native cultures is symbolized by the revival of canoe-building and community gatherings focusing on this important tradition. Every summer the Pacific Northwest now witnesses large groups of traditionally carved canoes being paddled by teams of pullers who have trained extensively to master the

strength, skill, and synchronicity that is required to move these large canoes through Pacific waters. There is a special protocol for coming to shore on another tribe's land, in which the paddle plays an important part. As the canoes come to shore, the paddles, each individually painted to represent the puller's family crest, are raised vertically as a greeting.

41 **Toadem Pole,** 2003, Maynard Johnny, Jr. Acrylic on paper; 22 1/4 × 9 inches. *Photograph by Tod Gangler.*

42 **Blue Heron,** 2003, Maynard Johnny, Jr. Acrylic on paper; 22 1/4 × 9 inches. *Photograph by Tod Gangler.*

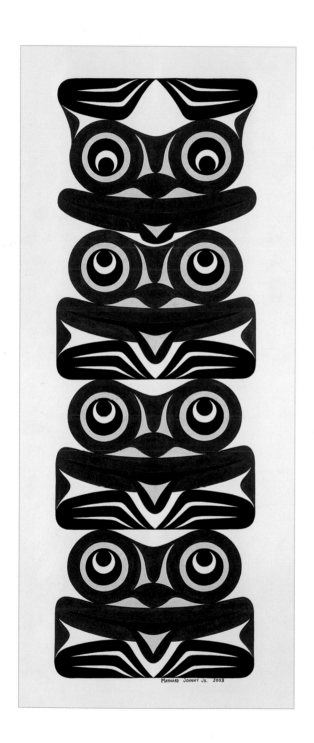

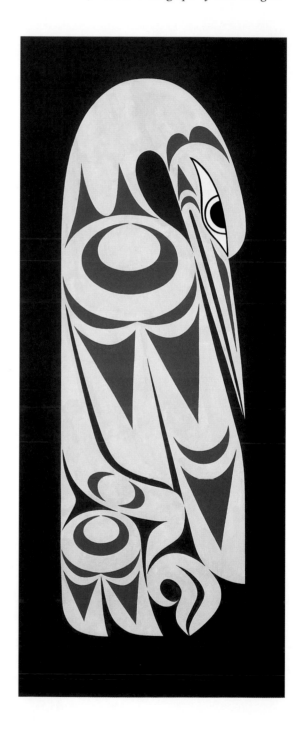

43 **Thunderbird Paddle,** 2003,
Maynard Johnny, Jr. Yellow cedar
and acrylic; 54 1/2 × 5 1/2 inches.

Luke Marston and John Marston

Through determined study of the work of their elders, Chemainus brothers Luke Marston and John Marston have assimilated and reinterpreted the Coast Salish oral histories and legends into a visual dialogue which honors the spoken word as well as the contemporary art style of their people.

Luke and John Marston (born in 1978 and 1976, respectively) grew up in a family of artists. Their parents, Jane and David Marston, are experienced carvers who provided their sons with an early introduction to art and carving. Luke and John Marston also credit respected elder Cowichan artist Simon Charlie as playing a significant role in their tutelage. Summers spent carving at the Royal British Columbia Museum in Victoria, British Columbia, afforded them the opportunity to further their artistic and cultural educations and better interpret their Cowichan culture through their art. What is unique about the brothers is their interest in and inquiry into the more

44 **Shaman's Bowl** (front), 2003, Luke Marston. Wonderstone, 14-karat gold, and ivory; 12 × 8 × 6 inches. *Photograph by Janet Dwyer.*

45 **Shaman's Bowl** (back).

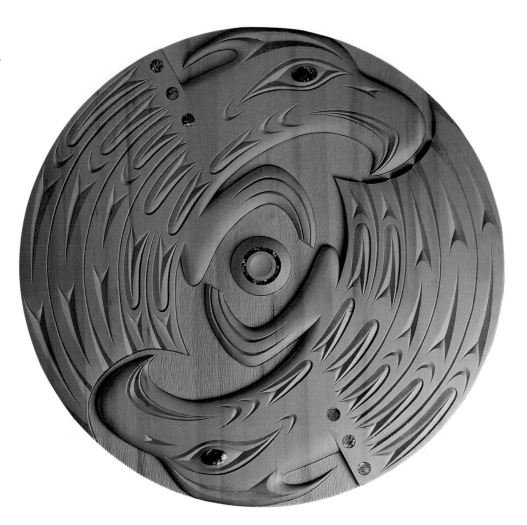

obscure Coast Salish artifacts from which they draw their inspiration. A prime example is Luke's *Shaman's Bowl*.

Luke Marston's *Shaman's Bowl* (figs. 44 and 45) is a contemporary rendition of the mysterious seated figure bowls believed to have been a sacred art form used by shamans. These bowls were unearthed throughout Coast Salish lands, but most frequently found in the Fraser River Valley. Like many examples of southern Northwest Coast and Coast Salish art, these bowls are more figurative than the carvings found to the north.

Through his research at the Royal British Columbia Museum, Luke Marston has gained insight into these intriguing ancient Coast Salish artifacts that date back as far as two thousand years. Shaman's bowls were generally four to twelve inches tall and usually carved from soapstone. The exact uses of these bowls remain uncertain; however, there are currently many viable theories as to why they were made. In his book *Images: Stone: B.C.* Wilson Duff states that similar bowls played a central role in a coming-of-age fertility ritual for young females. Another theory that Marston has researched suggests that bowls of this size were used to hold paint for face pigments in initiation ceremonies. Others believe that shamans would mix hallucino-

genic medicinal concoctions in them—often with tobacco, which was considered a sacred ingredient that only the highest-ranking people had the right to use. It is possible that a particular concoction mixed by the shamans included rattlesnake venom, indicated by the spines of the carved figures which often resembled snakes. Some of these bowls could have acted as guardians or protectors at gravesites, and it is thought that the ones containing poison may have been intentionally placed at these sites to deter animals.

John Marston chooses to portray another important Salish artifact in his *Thunderbird Spindle Whorl* (fig. 46). For the contemporary Coast Salish artist, the spindle whorl has been reborn as an icon to globally identify their cultural lineage. The spindle whorl has been used by Coast Salish women for centuries to spin their wool into yarn. The oldest whorls discovered by archaeologists were carved from stone, and were typically incised with imagery. Following this tradition, spindle whorls continued to be carved, but eventually were made in wood. When the spindle whorl is in use, the images spin around, animating the creature or design carved into the whorl. One can imagine being transfixed by a design similar to Marston's, with two great thunderbirds carved head to tail, locked in perpetual flight as the wool is spun into yarn.

With *Thunderbird Spindle Whorl* John Marston pays tribute to the weaving traditions of his ancestors and also to the tales told about Thunderbird and the Cowichan people. Within Coast Salish stories there are four different worlds: the Sky World, the Spirit World, the Mortal World, and the Undersea World. The mythic Thunderbird lives in the Sky Kingdom. This carving was inspired by the Cowichan Thunderbird story that has been told to him many times since his childhood. One version of this tale is the "Legend of Thunderbird Rescuing the Cowichan People from Starvation," as told by Simon Charlie (p. 71).

Another sky being in Salish mythology is Raven, portrayed as creator and bringer of light throughout the Northwest Coast. The grace and elegance of John Marston's *Raven Rattle* (fig. 47, top) honors both this character and the sacred and integral role of rattles in Native life. Marston explains, "This is my contemporary version of an old Cowichan ceremonial rattle. Rattles such as these were commonly very plain in design, but rich in form. They continue to play an important role in our ceremonies, including marriage, coming-of-age, and the tribe's salmon homecoming celebration."

Bill Holm's book *Spirit and Ancestor: A Century of Northwest Coast Indian Art at the Burke Museum,* features a Quinault ceremonial rattle (fig. 47, bottom) that John Marston has admired for years (pp. 36–37). These rattles were used in the Klookwalli ceremony, a winter ceremony practiced by the Quinault and other tribes of the southern part of the Northwest Coast. The

47 **Raven Rattle** (top), 2004, John Marston. Yellow cedar, abalone, and acrylic; 7 × 3 × 10 inches.

Quinault Ceremonial Rattle (bottom), 2004, John Marston. Yellow cedar, abalone, and pigments; 7 1/4 × 4 × 11 inches.

globular shape, flat breast, and simple form are all typical of Klookwalli rattles. The colors of Marston's Quinault ceremonial rattle are similar to those of the rattle featured in Holm's book. Marston states, "I wanted to make an old rattle new."

During a slide presentation given by Bill Holm, John Marston was particularly impressed with an image of an older rattle that had a hole carved out of the center. That image stayed with him through the years, and Marston used the concept in his contemporary Coast Salish rattle (fig. 48) to portray the creation legend of the Cowichan people.

48 **Contemporary Coast Salish Rattle,** 2004, John Marston. Yew wood, abalone, and acrylic; 11 × 5 × 4 inches.

According to the legend, the first Cowichan fell to earth through a hole in the sky. His name was Syalutsa, to whom the Cowichan accredit the creation of many of their traditions, including gift-giving, the winter ceremonies, and ritualistic bathing in rivers and streams to attain a communion with the spirit world.

The second being to fall to earth through the hole in the sky was Stutsun, who became Syalutsa's brother. To help Stutsun understand this new world, Syalutsa sent his brother on a long journey. On his adventure, Stutsun encountered different beings, including the Double-Headed Serpent and Thunderbird (Marshall, 1999). Marston has carved both of these figures into his rattle and wrapped them around the hole in the sky to depict the beginning of Cowichan time.

Simon Charlie
COWICHAN /
KWAKWAKA'WAKW

*Jane Marston
(Kwatleemaht)*
CHEMAINUS

Stan Greene (Eyi:ye)
SEMIAHMOO/CHEHALIS/NEZ
PERCE

Andy Wilbur-Peterson
SKOKOMISH/SQUAXIN

*Ron Hilbert/Coy
(čadasqidəb)*
UPPER SKAGIT / TULALIP

Roger Fernandes
LOWER ELWHA S'KLALLAM

Keeping the Spirit Alive

THE FOUNDATION FOR CONTEMPORARY Coast Salish art has been laid by the elders who worked to keep their languages alive, and who passed on the traditions of weaving, carving, fishing, and gathering to their apprentices. Artists such as Simon Charlie, Roger Fernandes, Stan Greene, Ron Hilbert/Coy, Bill and Fran James, Jane Marston, Andy Wilbur-Peterson, and Bruce Miller have dedicated their lives to teaching traditional Coast Salish arts, quietly and persistently passing to the next generation all that they have learned. Their values are reflected in their lifestyles: their living within or close to their tribal lands, reverence for and masterful understanding of traditional materials, and immersion in ceremony, tradition, and family.

Simon Charlie

Simon Charlie is a master carver and elder of the Cowichan Coast Salish tribe who is loved and revered for his lifelong commitment to keeping the traditional Coast Salish art and culture alive for his children and for future generations. Born in 1919, at eighty-six he continues to carve eight hours a day, every day, and finds the wealth of Coast Salish stories an infinite inspiration for his art. His style of carving speaks to his gift for storytelling, and his abounding energy pervades every carved and painted area. Charlie's work has touched many countries and cultures around the world. One of his totem poles was presented by the Chiefs of British Columbia to the government of Canada and now stands in front of the parliament buildings in Ottawa.

49 **Thunderbird and Killer Whale,** 2003, Simon Charlie. Red cedar and acrylic; 19 1/2 × 16 × 18 inches.

Legend of Thunderbird Rescuing the Cowichan People from Starvation

Charlie's carving Thunderbird and Killer Whale *(fig. 49) depicts the legend of how Thunderbird saves the Cowichan people from starvation, and features Thunderbird and Killer Whale, two key figures in Coast Salish mythology. In this legend, as told by Simon Charlie, it is made clear how dependent the Coast Salish were on the returning salmon runs. The Coast Salish people, like other Native peoples of the Pacific Northwest Coast, harvested the salmon, then dried the fish and used these stockpiles for winter sustenance.*

IN ANCIENT TIMES, KILLER WHALE BECAME trapped in Cowichan Bay. The whale had the fortunate position of being able to feast on all of the salmon as they journeyed from the sea back to the rivers. While this was ideal for Killer Whale, the people of the villages up the river were starving. They relied on the abundance of the returning salmon to sustain them. Distraught, the villagers called on the Creator to help them in their time of desperation. In answer to their pleas, Thunderbird, an enormous supernatural being with an insatiable appetite for whales, descended from the skies. As Thunderbird spread his great wings, lightning flashed from his eyes and thunder rolled forth across the sky. Thunderbird swooped down and grabbed Killer Whale with his talons and flew to a faraway mountaintop to enjoy his feast. The salmon could then make their way up the rivers to spawn and the people could again rely on this abundance for food. Grateful for the return of the salmon, the people honored Thunderbird with a prayer and dance of thanks.

Jane Marston

Chemainus artist Jane Marston, or Kwatleemaht, has done extensive research into Northwest Coast Native culture and has formed an apprenticeship with world-renowned master carver Simon Charlie. Marston teaches at the Simon Charlie Society in Duncan, British Columbia, as well as at Malaspina College in Nanaimo, British Columbia. Although Marston is able to touch many as a teacher and lecturer, it is through her art that she can best express the love and respect she has for her people and her culture. She has honed her skills as a carver of Native dolls in authentic costumes, totem poles, and ceremonial masks.

Jane Marston fondly recalls sitting on a beach as a child, listening to her

great-grandmother, Hwal lee qul lut, as she shared the story and sang the song of the spirit baby dolls. These dolls were central figures in a fascinating (and nearly extinct) ceremony from Coast Salish culture many years ago. According to Hwal lee qul lut, the spirit baby dolls were carried by the women into the big house for family gatherings. At one point in the gathering, the song of the spirit baby dolls would begin, and the first doll would rise and dance around the table. When the song was finished, it would sit back down. When the singing resumed, a second doll would lift and fly around the big house, moving in and among the guests. The dolls were almost always in pairs: one danced and the other flew through the air. It was believed that the spirit baby dolls bestowed good feelings and blessings to all present.

Marston's hand-carved *Spirit Baby Doll* (fig. 50) wears a traditional handwoven Coast Salish dress and is inspired by her maker's vivid memories of being transported back in time to a place that is largely unknown today. This invaluable time spent with her great-grandmother forged a link to the past, ensuring that this rich story will not be lost. To Marston's knowledge, this is the first spirit baby doll created in recent times.

50 **Spirit Baby Doll,** 2003, Jane Marston. Western red cedar, wool, fur, leather, abalone, and cedar bark; 16 × 11 × 8 inches.

51 Human with Thunderbirds Spindle Whorl, 2003, Stan Greene. Western red cedar; 11 1/4 inches diameter.

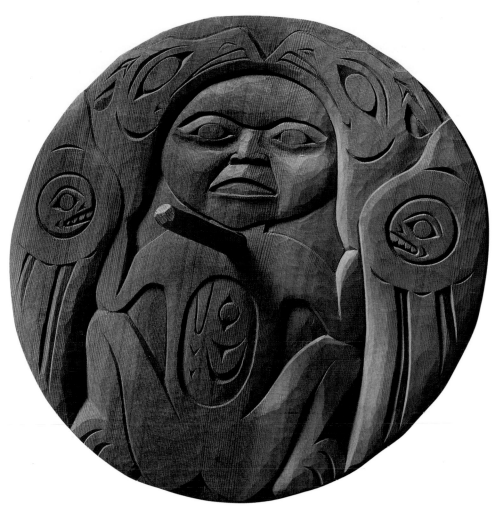

Stan Greene

Stan Greene, or Eyi:ye, is of both Coast Salish (Semiahmoo-Chehalis) and Nez Perce (Joseph clan) descent, and has dedicated himself to preserving his cultural heritage for future generations. Greene's grandfather, Billy Harris, taught him to carve at a young age. In 1977 Greene attended the 'Ksan School of Art and Design in Hazelton, British Columbia, where he was taught the Tsimshian style of art. Greene used his knowledge of the rules of this northern-style design to comprehend and recreate the Coast Salish designs he came across in his studies at regional libraries and museums. A leader in the revival of the Coast Salish artistic traditions, Greene has become a role model for Coast Salish people who want to rediscover their cultural inheritance in carving and design.

Greene is esteemed by other Coast Salish artists, including Susan Point, for being the first contemporary artist to adopt the imagery of the old spindle whorl. The spindle whorl, with its elegantly carved shapes, is at once a tool and an object of beauty, synthesizing form and function, an icon evoking Coast Salish culture in precontact times.

73

The Coast Salish people believe in transformation and personal encounters—both spiritual and physical. Stan Greene encountered a thunderbird during a spiritual journey, who claimed him and bestowed great blessings upon him. Greene explains that his spindle whorl *Human with Thunderbirds* (fig. 51) represents the joining of the artist and thunderbird as one. The carving shows a man seated in the center, flanked on each side by thunderbirds (Shxwxuos), identified as such by the crowns, or horns, on their heads. The face of the man can be seen inside each wing of the bird. The salmon design inside the man's belly indicates that the man is full and content. This piece is based on one of Greene's favorite old spindle whorls (featured in Brown's essay, fig. 8), the same one that inspired his 1979 print, *Human with Thunderbirds,* the first Coast Salish print produced by a Coast Salish artist.

Andy Wilbur-Peterson

Skokomish-Squaxin artist Andy Wilbur-Peterson and his wife Ruth Wilbur-Peterson were among the first contemporary artists to depart from working in the northern style and move toward developing their own Coast Salish style. This transition was achieved by studying the Coast Salish artifacts at the University of Washington's Burke Museum and at museums in British Columbia, as well as studying the Coast Salish artwork created by Andy's great-grandfather, Henry Allen.

Over the years, Wilbur-Peterson has developed his own individual style within the southern graphic design system. This bold move has influenced other Coast Salish artists to individualize their art. His carvings and serigraphs are at once recognizable as both Coast Salish and as Andy Wilbur-Peterson's.

Wilbur-Peterson is renowned for his bentwood boxes, which provide the ideal canvas for his interpretation of the old Coast Salish stories. Bentwood boxes are produced by kerfing and steam-bending planks of cedar. Traditionally, they had both utilitarian and ceremonial purposes, and were usually adorned with stylized designs portraying tribal stories, legends, and histories. Wilbur-Peterson has carved and painted the legend of Frog and Bear onto this bentwood box (fig. 52).

52 **Frog and Bear Bentwood Box,** 2003, Andy Wilbur-Peterson. Western red cedar and acrylic; 17 × 17 × 19 3/4 inches.

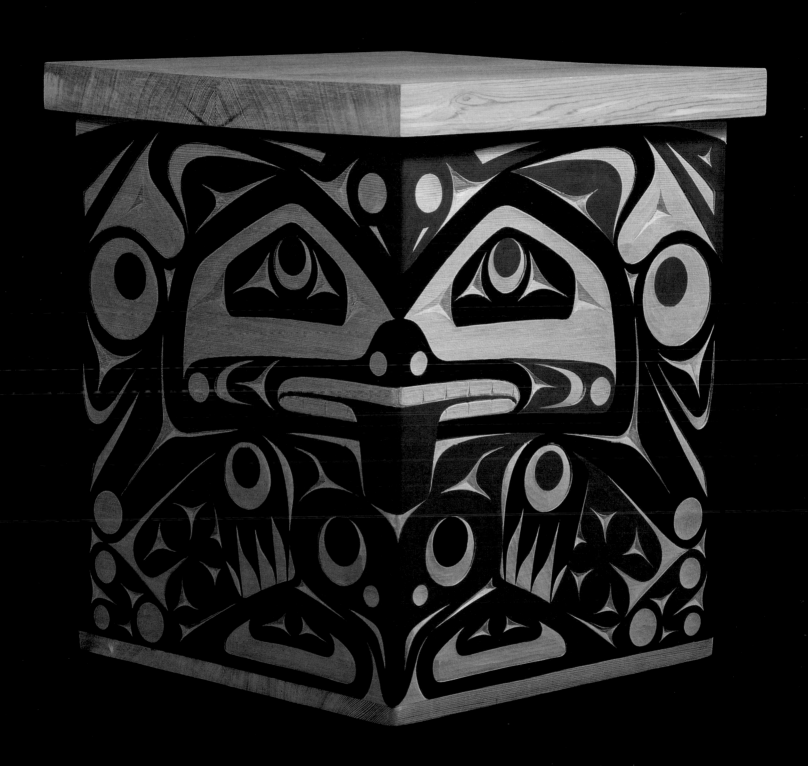

Legend of Frog and Black Bear

Andy Wilbur-Peterson relates the legend of Frog and Black Bear that portrays the consequences of greediness.

53 **Fishing for Bullheads,** 2003, Andy Wilbur-Peterson. Western red cedar and acrylic; 41 1/2 × 15 1/2 × 3 inches.

T WAS GETTING ON LATE SUMMER, AND BLACK Bear was foraging for food. Everyone knows that frogs are one of Black Bear's favorite foods. Now Blue Jay and Black Bear were friends, and they both liked hosting meals for each other. Black Bear was getting sleepy, and was looking for more food to sustain him over the winter months. The frogs were already burrowing themselves into the mud, where they stay frozen for the duration of the winter. Black Bear was getting desperate, not being able to find them.

Blue Jay was a wheeler and a dealer. Watching the hiding frogs from the top of an old cedar tree, he started scheming. Swooping down to talk to Black Bear, he asked, "Are you hungry, my friend? Come with me and I will make some tadpole soup." Upon arriving at Blue Jay's house, Blue Jay said to Black Bear, "Oh, there's a hole in my water box, and my tadpoles are gone." So Black Bear cut his paw to drip some grease for Blue Jay, his friend. Now that Blue Jay had his belly full, he said, "My friend, that was good. May I return the favor? I know that you see poorly, let me be your eyes. I have been watching from atop my house and there are four frogs at the base of my lookout and they are buried deep in the mud. Tomorrow I will show you where. Now go home, and sleep."

Black Bear went home and, meanwhile, Blue Jay propositioned the frogs. Blue Jay said, "Black Bear is coming in the morning and he knows where you are. If you give me some of your tadpoles, I will distract him." The frogs agreed. The next day Blue Jay told Black Bear that the frogs were buried in the mud. He told Black Bear to jump and the tadpoles would ooze out. Blue Jay shouted, "Jump!" and Black Bear began to jump. Blue Jay got so excited at seeing the tadpoles that he got in the way of Black Bear. Black Bear, not seeing so well, grabbed his friend by the top of his head and pulled his hair out. That's how Blue Jay got his top notch. Then the frogs nearly pulled Blue Jay under the mud. That's why Blue Jay hops. Blue Jay's loss and injury teach us about the ill effects of greed.

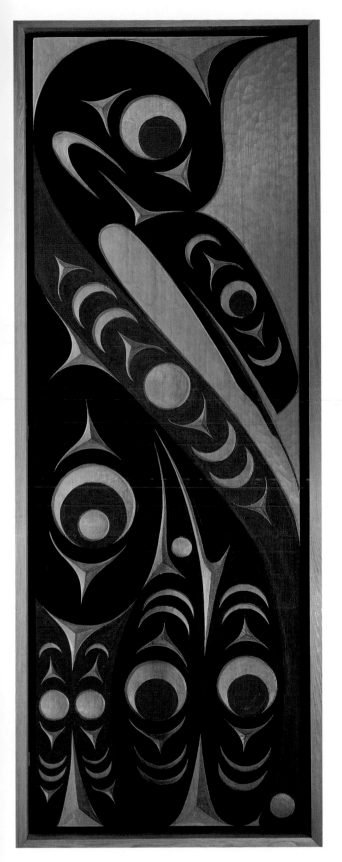

Growing up on the Skokomish Reservation, Wilbur-Peterson recalls hearing many tales of animals with human attributes. Like Frog and Black Bear, Crane figured prominently in the tales of the Skokomish. Wilbur-Peterson's carved and painted cedar panel *Fishing for Bullheads* (fig. 53) depicts a traditional interpretation of a creature known throughout the lands of the Coast Salish people—the crane.

Legend of Fishing for Bullheads

This is the tale of the tragic romantic triangle caused by Helldiver, as told to Wilbur-Peterson by his late grandfather, the Skokomish storyteller and canoe carver Henry Allen.

CRANE, WHO WAS HARDWORKING and industrious, was married to Helldiver, a woman who had a wandering eye. One day, Helldiver noticed Sawbill drifting down the river and immediately she fell in love with him. She pretended she was sick and begged her husband, "Crane, please go catch bullheads for me." Crane obliged, but when he went to catch them, his legs would splash in the water and scare the bullheads away. The inventive Crane whittled his own legs down and continued to catch the bullheads for Helldiver, who was off frolicking with Sawbill.

In the course of the day, Crane got into a fight with Kingfisher over his fishing grounds. He stabbed Kingfisher under the wing, where a red spot remains today. Kingfisher got angry and told Crane about Helldiver and Sawbill. Feeling betrayed and upset, Crane returned home and rubbed his wife's head with hot coals until her eyes turned red, as they still are to this day.

Ron Hilbert/Coy

Upper Skagit artist Ron Hilbert/Coy's (or čadasqidəb's) paintings of Coast Salish smokehouse ceremonies have provided rare and personal documentation of one of this culture's most important and sacred ceremonies. In his painting inspired by a photograph in the Smithsonian Museum's collection, Hilbert/Coy portrays the powerful and respected Swinomish Indian doctor Tommy Bob performing a cleansing ceremony with his spirit boards at the Swinomish longhouse in 1932 (fig. 54). Black-painted dancers are the tribe's warriors. Red-painted dancers are the tribe's healers. The roles are self-determined: The dancers look to their own inner spirits for the guidance to understand if their nature is best represented by the black paint or the red paint.

Power boards like those seen in this painting are used primarily in healing rituals by the Puget Sound Natives' doctors or shamans. The healer sings a song and the power of the song propels the boards to move through the smokehouse, urging the men carrying the boards to keep pace with the song.

The artwork of Hilbert/Coy is found in many collections, including

54 **Tommy Bob running his Sqʷadəličat [spirit board] at the Swinomish 1932 longhouse,** 1984, Ron Hilbert/Coy. Acrylic on canvas; 15 1/2 × 50 inches.

those of the Seattle Arts Commission and Daybreak Star Cultural Center. His illustrations are featured by his mother, Upper Skagit elder Vi Hilbert, in her book *Haboo: Native American Stories from Puget Sound,* and in Robin Wright's book *A Time of Gathering: Native Heritage in Washington State.*

Roger Fernandes

Roger Fernandes, a member of the Lower Elwah band of the S'Klallam tribe, is a versatile artist who has explored painting, drawing, print-making, and sculpture, while also working in graphic design and illustration. He is noted for constructing classic Coast Salish designs from cut paper to translate the rich oral histories of the Salish peoples into two-dimensional representations. This particular technique allows Fernandes to work within positive-negative design principles, yet affords him a unique medium of expression. Fernandes received a degree in Native American studies from the Evergreen State College in Olympia, Washington. He has taken on private and public commissions across the region, including commissions for the Seattle Arts Commission and the King County Arts Commission.

One of the most revered roles in Coast Salish society is that of the story-

teller. Since 1955, Fernandes has actively cultivated this tradition, becoming one of the most sought-after Coast Salish storytellers. He particularly enjoys recounting these legends to school children.

Roger Fernandes's *Northwind, Southwind, Stormwind* paper cut (fig. 55) pays tribute to the myth that explains winter's tempestuous weather (see Susan Point's "Legend of Northwind's Fishing Weir," page 39, and Shaun Peterson's *Spirit of the North Wind,* page 60). Fernandes explains why this particular legend has a special importance for school children of the Puget Sound region:

"The 'Northwind's Fishing Weir' myth is a powerful story that explains the phenomena of the great winds that pass through Puget Sound every year. North Wind [Ste-blah] comes in November and marks the beginning of winter, a time of ice and snow and darkness. One world has ended. South Wind [also known as Storm Wind, Chinook Wind, or StewauX] comes in April and marks the beginning of spring. He drives North Wind out of the land. A new world begins.

"This mythic story explains such phenomena, but also instructs as to how human beings live and learn. A powerful mythic teaching within the story is how the young Storm Wind [Sxatselatchi] is instructed to never go up a nearby hill. Unbeknownst to him, his paternal grandmother lives there. One day he decides to defy the instructions and goes up the hill, finding his grandmother and learning the truth of his life and his destiny. The teaching could be interpreted to say that if we always do what other people tell us, we may never find the true purpose of our own life."

55 Northwind, Southwind, Stormwind, 2004, Roger Fernandes. Cut Mexican bark paper; 13 × 16 inches.

Fran James
(Che top ie)
LUMMI (XWLEMI)

Bill James (Tsi'li'xw)
LUMMI (XWLEMI)

Bruce Miller (subiyay)
SKOKOMISH (TUWADUQ)/
YAKAMA

Karen Reed
CHINOOK/PUYALLUP

Michael Pavel
(chixApKaid)
SKOKOMISH

Susan Pavel
(sa'hLa mitSa)
NATIVE HAWAIIAN

Ed Archie NoiseCat
STILITLIMX (INTERIOR
SALISH)/SHUSWAP

Krista Point
MUSQUEAM

Weaving the Generations Together

N THE QUIET OF THE FORESTS, IN THE MEAD
ows, and along the shorelines the weavers begin their work the same
way previous generations have done—with the gathering and
processing of natural materials. In spite of the many centuries that
separate modern Coast Salish weavers from their ancestors, today's
artists continue to employ the same exacting techniques and disciplines,
using the same materials to make exquisite functional baskets and luxu-
rious blankets. Possibly more than any of the other arts, the weaver's art
may be the most reverently connected with the past.

Fran James and Bill James

In a day and age when human activities are evaluated in terms of efficiency and timeliness, weavers Fran James (Che top ie) and her son Bill James (Tsi'li'xw) of the Xwlemi Nation are among those who partake in a meticulous, time-honored art form without compromising the processes of hand-producing their craft. Fran James, born and raised in Lummi, Washington, comes from a long line of basket weavers, including her grandmother and all of her aunts. She is among the best-known basket weavers of the Pacific Northwest, and her work has been featured in numerous publications and documentaries. She has inspired many younger people to learn the craft of basketry, and she continues to teach weaving and share her knowledge with her students.

When Bill James was a teenager, his great aunt taught him how to weave baskets in the traditional Coast Salish style. He later learned to weave wool while studying at the Institute of American Indian Arts in Santa Fe, New Mexico. He has now been weaving baskets and blankets for over thirty years.

56 **Lummi weaver Fran James (Tsi'li'xw)** weaving a cedar basket at her home. *Photograph © Mary Randlett 1986.*

57 Me Hoy' Cedar Bark Basket,
2003, Fran James and Bill James.
Inner bark of the western red cedar,
wild cherry bark, wild rye grass,
raffia, and natural dyes; 5 1/2 ×
10 inches.

Swo'qw'lh, Coast Salish Blanket,
2003, Fran James and Bill James.
Wool; 9 × 48 × 1/2 inches.

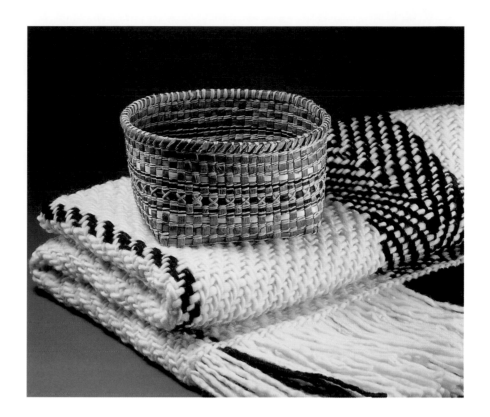

James teaches his students at the Northwest Xwilmexw College to carry on
the traditional arts of weaving and spinning wool.

Much of the time that goes into making a basket is expended gathering
the materials. The materials for the *Me Hoy'* basket (fig. 57), cedar and wild
cherry bark and grasses, were gathered in Whatcom County, where Fran
and Bill James live.

The inner bark of the cedar tree has been the staple material used in
Coast Salish basket weaving for centuries. Ironically, the once ubiquitous
western red cedar tree is now the most challenging material for weavers to
find and gather. Rampant clear-cuts have made the tall, straight trees vir-
tually extinct.

The dark and light bands create a striking area of contrast on this piece.
The dark band in this basket is wild cherry bark. The white band is native
rye grass gathered in the fall.

The time for gathering the cherry bark is dependent on the elevation of
the tree and the time of year. The objective is to carefully peel a narrow strip
of bark in a continuous long spiral from around a branch when the sap is
running strongly. The tree will heal over in a year's time. Fran and Bill James
will not visit the same tree twice.

The *Me Hoy'* basket was woven using the plaiting (under and over) tech-
nique. This type of basket was used for everyday activities such as carrying
and serving food and gathering berries.

In addition to their basketry, the Jameses are nationally recognized for their traditional Coast Salish blankets. Contemporary Coast Salish blankets are created, for the most part, using traditional weaving techniques, primarily with hand-spun sheep's wool. After the wool is shorn, it is carded and spun into yarn. It typically takes one hundred hours or more to weave each blanket on a floor loom. Salish blankets were historically woven with the wool of mountain goats (*sxwi'tl'i*) and small dogs (*ske'xe*). Cattail fluff and shredded cedar bark were sometimes added to give the blankets additional loft. These materials, though harder to find than they once were, are still used in blanket weaving.

Fran and Bill James's blanket, *Swo'qw'lh* (fig. 57), is patterned after historic Puget Sound Coast Salish wool blankets using the traditional herringbone weave and chevron patterns, as well as all-natural undyed sheep's wool. This boldly designed blanket was made specially for a man. The Jameses' signature mark is the brown four-strand vertical stripe down the center.

Today young members of the Coast Salish community use these blankets in ceremonies ranging from the naming of a young person to weddings and funerals. After the ceremony, the blankets will usually be offered as gifts to the elders.

Bruce subiyay Miller

Bruce subiyay Miller is of Skokomish (tuwaduq) and Yakama heritage. He is the fourteenth of fifteen children, and was raised in a traditional extended-family household of more than twenty-one people. Miller, who studied basketry with his two grandaunts, grew up surrounded by baskets, weavings, and ceremonial objects. In his youth, Miller's tribal elders identified him as one who could be taught and trusted to pass on traditional Skokomish weaving techniques. His customary training in the culture and oral tradition of his tribe began in 1948 at the age of four, with his great-grandmother (born in 1861), culminating in the mastery of the Skokomish tribal language. He is the keeper of a repertoire of more than one hundred and twenty traditional stories, some of which take days to tell. Miller also maintains a large collection of ceremonial songs and dances, which have enabled him to help revive such ceremonies as the First Salmon and the First Elk, and to bring winter ceremonies back to his people.

Miller is the chief and elder of the Skokomish people who still adhere to the traditional ways, and has been an active artist for over forty years. He studied sculpture under renowned sculptor Alan Houser at the Institute of American Indian Arts in Santa Fe, New Mexico, and in 2000 he was named a "Living Treasure" by the Washington State superintendent of public

58 The Village of Gooseberry Point, 2003, Bruce Miller. Western red cedar bark, yellow cedar bark, bear grass, wild rye, Oregon grape bark, marigold petals, and blue-gray clay; 6 × 6 1/2 × 6 inches.

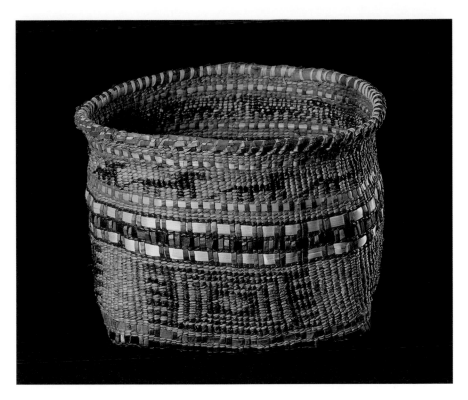

instruction for his lifetime work of teaching young people. In 2004 Bruce Miller was awarded the most prestigious honor bestowed by the National Endowment for the Arts, the National Heritage Award.

Miller's students are privy to centuries of accumulated cultural knowledge. Miller has passed down to his apprentices in the fiber arts the ancient methods of weaving blankets and baskets that he was taught by his elders. The myriad details an apprentice weaver must learn are intricate and complex—from the husbandry of and respect for the natural materials to the process of gathering the hair shed by mountain goats in spring to the methods of using natural materials such as stinging nettles, Oregon grape, and lichen—among many other plants—for dyes. Understanding the many uses of the western red cedar tree alone takes years to master, yet little by little, with each new skill and secret acquired, a new generation of Coast Salish weavers is established.

Miller's home garden on the Skokomish Reservation comprises over 260 indigenous plants, and provides many of the flowers and herbs used for dyeing his weaving materials. The yellow dye on the Twana basket in figure 58 comes from marigold blossoms from Miller's garden. On his front porch, every available surface is used to neatly store gathered materials. Cattail leaves and grasses are drying; cedar bark and cedar root are carefully split, coiled, and tied; and wild cherry and red alder are stacked in neat piles. Inside his home, one finds skeins of hand-spun wool hanging from the curtain rods. A partially finished blanket on one of his floor looms depicts the

legend of the frog snow (see completed weaving in fig. 59). Miller's home reveals a man whose art and life are one.

Bruce Miller is a descendant of several generations born in Gooseberry House at Gooseberry Point, which was located on the tideland of the Hood Canal on the Great Bend in Washington State. The house was part of a village that, along with five other adjacent villages, was destroyed by the United States government in an attempt to squelch the traditional Native culture of the region. The house faced the flounder beds that abounded in the freshwater estuaries of the Skokomish River as it flowed into Hood Canal. Miller recalls visiting the place where Gooseberry House had once stood, with his grandfather, who taught him how to fish for flounder there. The surroundings echo Miller's deep-rooted memories, including such profound moments as his first spiritual fasts. Miller's mentor, Louisa Pulsifer (qWatablu) was born there in 1881; Miller's other mentor, Emily Miller, was born in an adjacent longhouse in 1890.

Miller's *The Village of Gooseberry Point* basket (fig. 58) is a tribute to the lineage of basket makers from Gooseberry Point who mentored him. This basket is called *tqayas* in the tuwaduq (Skokomish) language, which Miller translates as a signature of his basket-making lineage. The materials gathered and techniques incorporated are specific to a certain region's creative legacy. The style of this classical Skokomish basket signifies the line of teaching Miller studied to create it.

This basket was woven using one of the many twining techniques used by the tuwaduq. It is tightly twined and packed. The rim pattern is of wolves facing right, the central motif is a garter snake, and the bottom design represents the flounder beds in a telescoping set of wealth boxes. The fringe-like design on the right and left edges of the wealth boxes represents herring grass. The double reverse twill base is Miller's signature.

Miller achieved the rich colors of this basket using all natural dyes: Oregon grape for the yellow, marigold for the orange, and blue-gray clay for the black designs.

Using a similar array of natural dyes, Miller also formulates an assorted palette of colors for his woven wool creations, such as *Frog Snow Blanket* (fig. 59). To the Coast Salish, the frog is honored as the keeper of the sacred seasons, and plays a critical role in marking the yearly cycles. In springtime, the voices of the tree frogs announce the beginning of a new cycle, heralding the culminations of the winter dance and ceremonial season and the approaching spring. The cycle begins in mid- to late February, with the emergence of salmonberry sprouts, accompanied by the first croaking of the frogs. Soon after the frogs begin singing, a sleet falls, known as salmonberry snow, bringing with it the salmonberry blossoms.

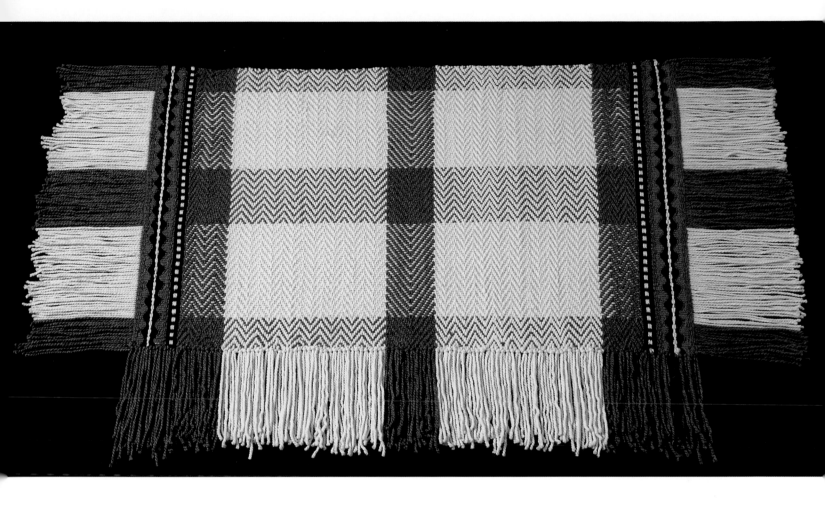

59 Frog Snow Blanket, 2003,
Bruce Miller. Hand-spun wool, wool
blend, and lichen dye; 60 × 47
inches.

Miller's *Frog Snow Blanket* celebrates this passage from winter into spring. Each color represents a different stage of the season: the white fields signify the initial frog snow; the pewter gray and white panels correspond to the salmonberry snow; and the solid gray is spring downpours. Green symbolizes the salmonberry sprouts shooting through the cool spring earth; and the bright pink areas, dyed with lichen, portray the salmonberry blossoms. A light dusting of frog snow, indicated by a white line, separates the blossoms and the sprouts.

Karen Reed

Karen Reed was born in 1949, and is of Chinook and Puyallup descent. She graduated from the University of Washington in 1978. Reed learned weaving from her grandmother, Hattie Cross (Skokomish), and from Beatrice Black (Quiliuete). Anna Jefferson, a highly respected Lummi weaver, taught Reed the important skills of gathering and preparing materials indigenous to western Washington, and her influence can be seen in many of Reed's baskets, especially the double-walled celebration basket known as *wabutt.*

Reed has been invited to participate in many regional and national gatherings of artists and basket weavers. Reed cites as her greatest influences her parents, Hazel Pete (Chehalis) and Bruce Miller (Skokomish)—her mentors, teachers, and friends.

This collection of cedar bark baskets (fig. 60) by Reed exemplifies the many Coast Salish basket styles that were developed to meet the various needs of the Salish people. The size and type of weave were dictated by the basket's purpose.

Karen Reed was taught how to weave her cedar bark backpack (rear basket) by Anna Jefferson. This large basket was started upside down over

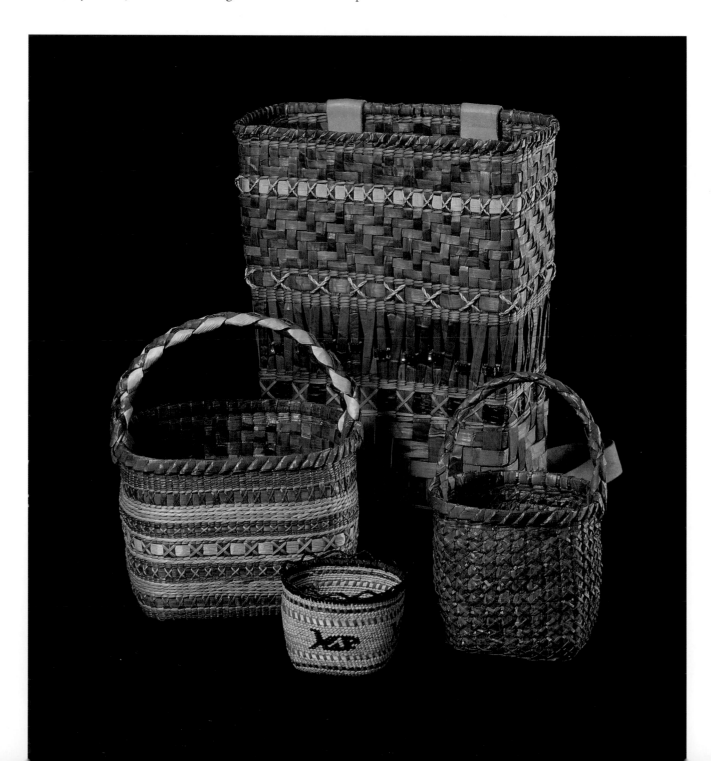

60 **Cedar Bark Backpack** (rear), 1995, Karen Reed. Western red cedar bark, yellow cedar bark, maple bark, birch bark, glass beads, and leather; 17 × 12 × 5 1/2 inches.

Coastal-style Small Cedar Basket (front), 2003, Karen Reed. Western red cedar bark, cattail, raffia, and mountain grass; 4 × 5 inches.

Double-wall Wabutt Celebration Basket (left), 2003, Karen Reed. Western red cedar bark, sweet grass, mountain grass, cattail, and yellow cedar bark; 12 × 9 1/2 inches.

All "X" Basket (right), 2003, Karen Reed. Red cedar bark, red cedar string, and woven red cedar handle; 11 × 6 inches.

a wooden frame, and was worked that way until enough weaving was completed so that it could be finished in its upright position. Reed made cordage from fresh sweet grass gathered in eastern Washington and used it to embellish the basket. The fragrant grass has retained its scent through the years.

Reed's coastal-style small cedar basket (front) has a red cedar bark frame and was woven from cattail fiber and raffia, with mountain grass overlay. The wrapped twining method was used to create a coastal design, depicting whales and canoes. The cattail fiber imparts a unique texture and appearance.

Reed's double-wall *wabutt* celebration basket (left) is a traditional celebration basket that would only have been used for special occasions such as naming ceremonies, weddings, memorials, and the like. When attending a potlatch or large gathering, guests would bring their *wabutt* baskets. The *wabutt* baskets held utensils for the feast, and could be used to carry home leftovers.

The bottom of the *wabutt* basket was woven from thick strips of red cedar bark. Strips of the same type are split and used to form a plain inner basket, which is made first. The outside strips are then split lengthwise to form the finer outer basket. The basket is detailed with sweet grass triple-twining—twining with red cedar string, mountain grass, and cattail fiber overlay—and a yellow cedar string "X" pattern. The handle is constructed from double red cedar strips and cattail fiber overlay.

The type of weave used in Reed's *All "X" Basket* (right) was employed to quickly make a strong, well-secured, and resilient basket that could be used for carrying berries and plants or storing dry food and herbs.

Cedar Legend

Karen Reed shares the following Northwest Coast Native story in connection with her love of weaving with cedar.

LONG, LONG AGO, WHEN THE WORLD WAS NOT as it is now, all the beings and things had voices. When the world was young, the river had a voice, the rock could speak, and they all listened to one another. A particular cedar tree loved to sing. Such a joy it was to hear the enchanting melody that creatures would travel from near and far to hear the singing: "Hi ya hey! Hi ya hi ya hey!" The singing was beautiful.

Time passed. The world was forming; creatures and lands were created. One day, the cedar tree stopped singing, without explanation. Everyone noticed. All was quiet! The four-legged ones wondered at the silence. The winged and water beings, rocks and water, all noticed this change.

After much discussion, they decided to present the cedar tree with a young sapling. Cedar tree was delighted with this gift and once again broke into her melody so cherished by the other forest beings. As the young tree grew, she was very protective, sheltering it from the sun and hovering over it during storms. The little tree grew and grew.

One day, the cedar tree noticed a change. She was becoming old. The wind had blown some of her top off and she was no longer growing. It seemed that when it was hot, the larger, younger cedar tree leaned over to shade her from the sun and tried to shelter her during storms. She wondered at this and asked, "What are you doing?" The younger cedar tree replied, "You took care of me when I was young and now it is my turn to take care of you."

Michael Pavel, Susan Pavel, and Ed Archie NoiseCat

Michael Pavel, or chixApKaid, is a Skokomish tribal member and ceremonial leader-in-training under Bruce Miller on the Skokomish Indian Reservation. Pavel has been immersed in the history, art, song, dance, and language of the Coast Salish cultures since the age of thirteen, and has been trained in the making of ceremonial items used in the spiritual practices of the Puget Salish peoples. He is also an associate professor of education at Washington State University and a nationally renowned researcher on Native American education issues.

Susan Pavel, or sa'hLa mitSa, a Native Hawaiian, has found herself at home in the Pacific Northwest, surrounded by the bountiful homelands of the Twana people located in the aquatic environment of the inland sea, its rich estuaries, and the Olympic mountains. She has come to deeply respect and value her husband's Coast Salish culture and traditions. She apprenticed under master Coast Salish weaver and Twana spiritual leader Bruce Miller for six years and is now a master weaver herself.

Stilitlimx artist Ed Archie NoiseCat grew up in British Columbia with his mother's people, the Canim Lake band of Shuswap Indians. He draws inspiration from his mother's plateau culture and from his father's people, the Stilitlimx, closer to the coast. The stories of his ancestors are the source of his innovative images. NoiseCat graduated from the Emily Carr College of Art and Design in Vancouver, British Columbia, where he studied printmaking. In 1986 he headed to New York to work as a fine art lithographer. He now resides in Santa Fe, New Mexico.

Legend of the Great Flood

The awakening of Mount Rose is described in this legend, which is told according to Skokomish oral history.

A LONG TIME AGO THERE WAS A GREAT storm that caused a catastrophic deluge. As the waters rose and the land was flooded, sqʷa hala tSut [Mount Rose in the Olympic mountain range] awoke. With the power to levitate, the awesome land mass rose above the water's surface. The clever ancestors of the tuwaduq [Skokomish] tied their canoes to the mountain and survived the flood.

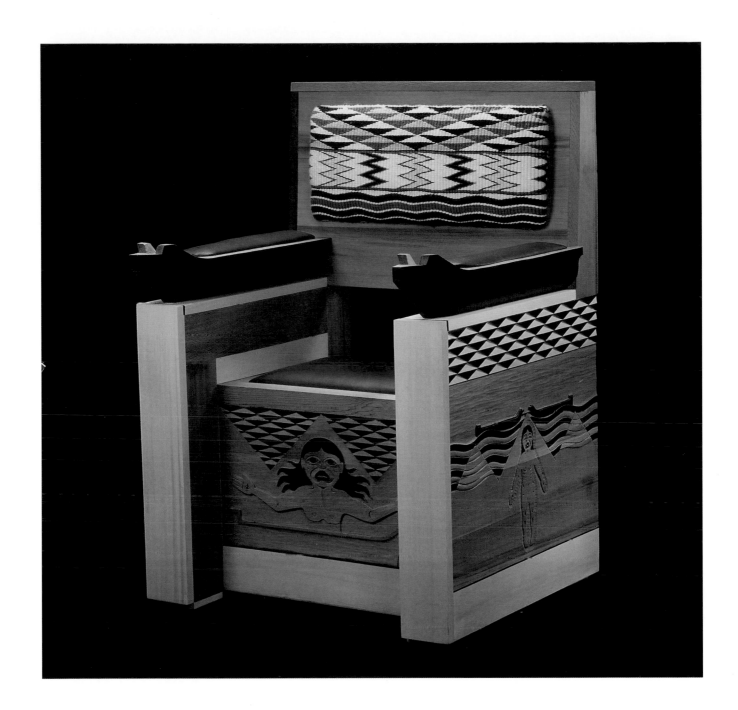

61 Awakening of sqʷa hala tSut,
Skokomish chief's chair, 2003,
Michael Pavel, Susan Pavel, and
Ed Archie NoiseCat. Western red
cedar, yellow cedar, leather, wool,
and acrylics; 41 1/2 × 28 × 27 inches.

The legend of the great flood has been illustrated on the panels of the chief's chair, *Awakening of sqʷa hala tSut* (fig. 61), a collaboration between Michael Pavel, his wife, Susan Pavel, and Ed Archie NoiseCat. Susan Pavel's traditional Coast Salish weaving on the chair back recreates the violent storm, with its dark foreboding clouds, lightning bolts, and rising flood waters. Ed Archie NoiseCat carved and painted the front panel, depicting the sleeping mountain, and the side panels, which celebrate its awakening. The armrests are stylized Salish canoes. Michael Pavel crafted the chief's chair from these individual carved and woven elements.

Krista Point

Krista Point was born in 1964 and is a member of the Musqueam Nation. She has been weaving for over twenty years and has displayed her work internationally. Point was inspired by the techniques her ancestors used to create their blankets long ago. The designs she uses are an accumulation of the various weavings she has completed over the years. Point chose these designs specifically to represent the Coast Salish people of the Musqueam Nation.

Weavings had many functions for the Coast Salish peoples, most notably as ceremonial objects. For wedding ceremonies, blankets would be woven in pure white and given to the bride. The blankets would be kept throughout the bride's lifetime, and when the woman passed on they would go with her to the grave. Weavings were also handed out to guests who traveled from afar to visit the longhouse.

Point's *Salish Flying Geese* (fig. 62) is a hand-woven blanket that incorporates a number of traditional Coast Salish weaving patterns. These include the left-right zigzags, the stacked triangles at the center, the wavy line of curved interlocking triangles in white and gold, as well as the artist's own abstract geometric designs. The first patterned band is made up of the Coast Salish lightning design, often associated with visions. This configuration is also interpreted as the zigzag trail left behind by a snake as it glides through soft dirt. Just below the lightning pattern is the flying geese motif, depicting a band of geese with outstretched wings.

Point describes the importance of color in her weavings: "The colors I use are natural colors. Yellow can be dyed from onion skins, dandelions, or goldenrod flowers. Green is dyed with stinging nettles, horsetail plants, and red onion skins. Red can be dyed with red alder bark. The goldish beige color is from lichen. The colors are energy forces that affect us positively or negatively, altering our moods and awareness."

62 **Salish Flying Geese,** weaving, 2003, Krista Point. Sheep's wool, onion skin dye, and stinging nettles dye; 3 × 4 feet.